SEEING THE LIGHT

Four Decades in Chinatown

PUBLISHER:

Chin Music Press

1501 Pike Place, Suite 329

Seattle, WA 98101

www.chinmusicpress.com

ISBN: 978-1-63405-903-9

First [1] edition

Book design: Dan D Shafer

Printed in Canada

LIBRARY OF CONGRESS CATALOGING-IN-PUBLICATION DATA

NAMES: Wong, Dean.

TITLE: Seeing the light : four decades in Chinatown / photos and essays by Dean Wong.

DESCRIPTION: First edition. | Seattle, WA : Chin Music Press, 2016. | Includes bibliographical references
 and index.

IDENTIFIERS: LCCN 2016009589 (print) | LCCN 2016012962 (ebook)
 ISBN 9781634059039 (hardback) | ISBN 9781634059053 (ebook)

SUBJECTS: LCSH: International District (Seattle, Wash.) Pictorial works. | Chinatown (Vancouver,
 B.C.) Pictorial works. | Chinatown (San Francisco, Calif.) Pictorial works. | International
 District (Seattle, Wash.) Social life and customs. | Chinatown (Vancouver, B.C.) Social
 life and customs. | Chinatown (San Francisco, Calif.) Social life and customs. | Chinese
 Americans Interviews. | International District (Seattle, Wash.) Biography. | Chinatown
 (Vancouver, B.C.) Biography. | Chinatown (San Francisco, Calif.) Biography. | BISAC:
 PHOTOGRAPHY / Photojournalism. | PHOTOGRAPHY / Individual Photographers / Essays. |
 PHOTOGRAPHY / Photoessays & Documentaries. | PHOTOGRAPHY / History.

CLASSIFICATION: LCC F899.S46 I588 2016 (print) | LCC F899.S46 (ebook) | DDC 979.7/77 dc23

 LC record available at http://lccn.loc.gov/2016009589

SEEING THE LIGHT

Four Decades in Chinatown

PHOTOS AND ESSAYS BY
DEAN WONG

TABLE OF CONTENTS

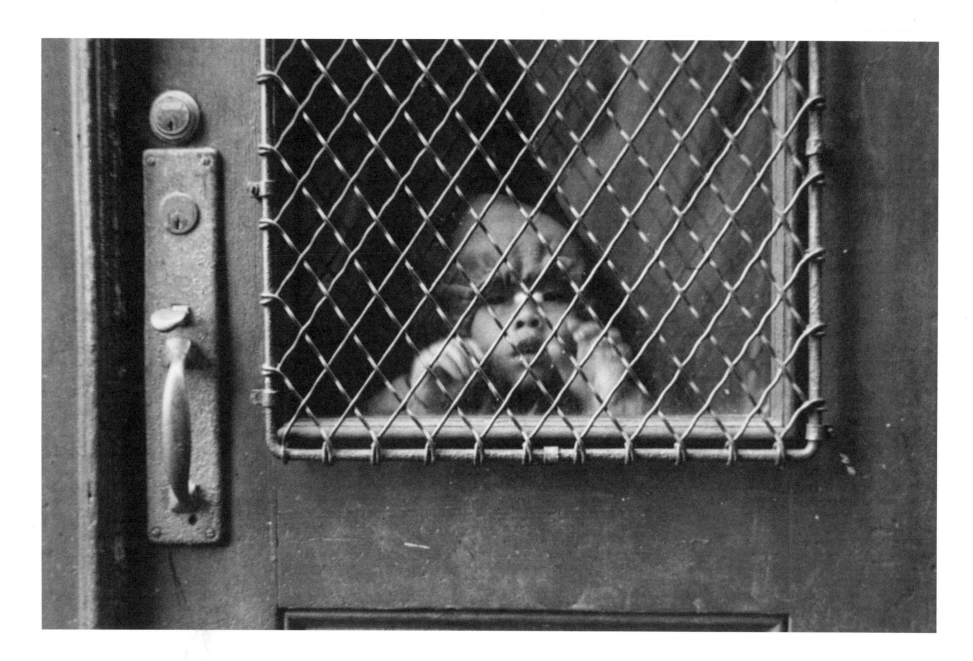

Herman. SEATTLE 1976

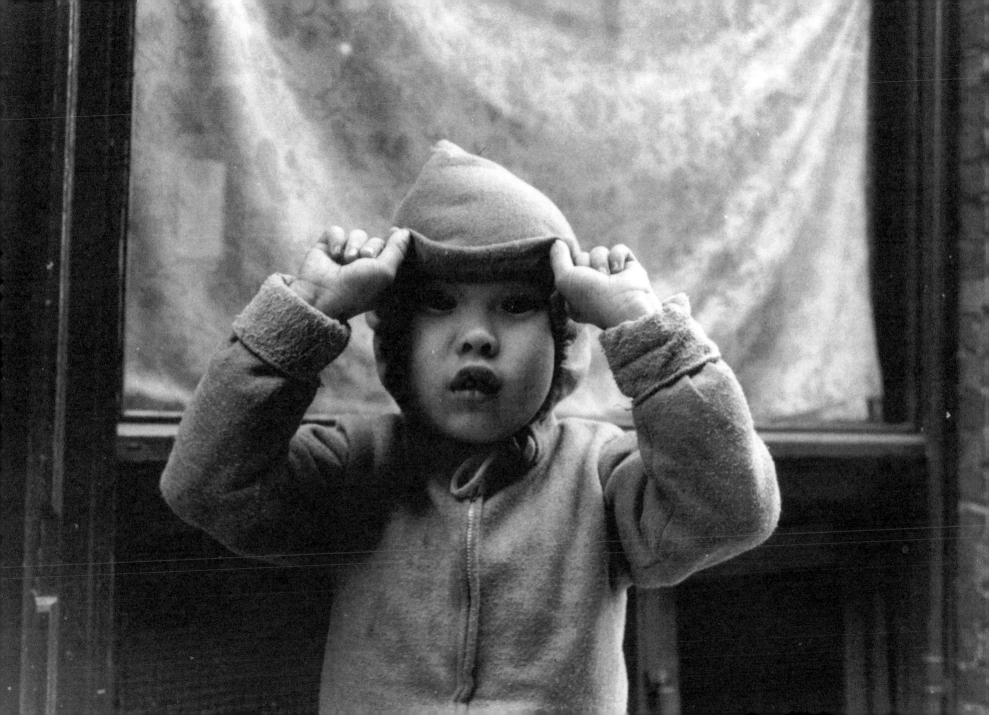

I

INTRODUCTION

*"You just have to live, and
life will give you pictures."*

Henri Cartier-Bresson

As a photographer, I've seen some amazing things come out of ordinary situations. All I had to do was capture it on film. A great picture is about the moment more than it is about light and exposure. A good negative is important to make a great print. But the photograph has to capture that fraction of a second in the human experience.

Henri Cartier-Bresson, the photographer who has inspired me the most, called it the *"decisive moment."*

As a photographer, I've been blessed with a visual curiosity. Each artist chooses which canvas to paint. For much of my career, I've chosen Asian Pacific America as the canvas for my life's work. With my cameras, I captured moments in time as they revealed themselves to me.

Community has been the heart and soul of my career. Seattle's Chinatown-International District has been at the core of my documentation efforts. I've also explored San Francisco Chinatown and to a lesser degree Chinatowns in New York, Portland, and Vancouver BC.

In 1976, I was drawn to a boy named Herman, staring at me from behind a Canton Alley door, his hands on the glass, behind a weathered screen, hoodie pulled over his head. It was the first photograph that meant something special. Herman was behind the metal grille of the door. I shot one frame on a roll of Tri-X film.

I'm second-generation Chinese American, born and raised in Seattle's Chinatown. My father, Milton Wong, owned the Little Three Grand restaurant by day. At night, he gambled at the pai gow tables and earned a reputation as a hatchetman, an old Chinatown term used to describe an enforcer.

When I was in in the fifth grade, father passed away.

My mother, Puey King Wong, ran the Re-New Cleaners on Maynard Avenue in the shadow of the Hong Kong restaurant with its iconic neon sign. She worked long hours in front of a press flattening shirts, and was a skilled seamstress, doing alterations with an ancient Singer sewing machine. To save money, she often did laundry by hand in the back of the shop, rather than sending it out.

Chinatown women would stop at the laundry to socialize. They'd tell my mother about the produce sales and shop for her since she would not leave the shop. Waiters would stop by for their uniforms. Filipino men called her "mama." They would return from the Alaska canneries with bags full of canned salmon to give my family.

I don't recall ever hearing my mother complain about the long hours and the hot days of summer spent next to the press. She wore simple dresses sewn with her own hands and made the clothes for her four children to save money.

"Of all the means of expression, photography is the only one that fixes a precise moment in time."

Henri Cartier-Bresson

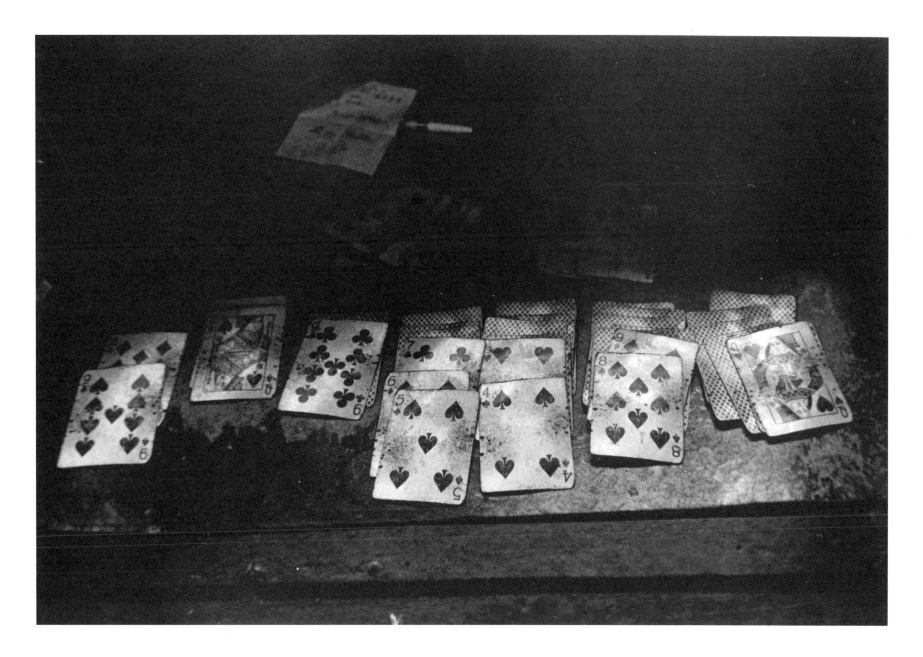

Solitaire. ORIENTAL CABS OFFICE, SEATTLE 1984

VANCOUVER, BC 1995

She finally retired after thirty-five years and found time to tend her garden. She enjoyed taking the number 36 bus around town for all the best deals in groceries. She passed away in 2012 at the age of 101.

My first camera was a Kodak Brownie. This was not something my parents would spend money on. I don't remember how I got the camera; perhaps it was payment for a gambling debt, just like the watches my father had.

During one Seafair Grand Parade, I walked downtown to photograph the Grand Marshall, Leonard Nimoy, who played Mr. Spock on *Star Trek*. I remember seeing him from a distance, signing autographs. Slowly I walked closer and closer. I wasn't close enough but I snapped the picture anyways.

I always enjoyed walking downtown to the drugstore to drop off my film.

Downtown was my escape, either to the main branch of the library to check out a *Hardy Boys* mystery or to do research for a school project. Other times, I'd stop at the Kress department store for a piece of fried chicken and a matinee at the Orpheum Theatre.

I don't remember much more about my early days as a photographer. I must have lost interest and did not pick up a camera again until high school.

My sister Faye had this Fujica rangefinder camera that she passed down to me. "It takes real good pictures," she told me.

I had no understanding of art. I might have seen a picture of the Mona Lisa in school and saw plenty of *LIFE* magazines growing up.

I recall taking the Fujica to Pioneer Square with my sister Jean. She was the artistic one and was planning to study graphic design in college. Jean owned a Nikon and passed on her knowledge of photography. She let me use her camera to further stimulate my interest in film.

The brick buildings in Pioneer Square caught my eye. I sensed the history in these aging structures, just like in Chinatown. I was fascinated by forms and photographed some poles with heavy metal chains wrapped around them.

At Cleveland High, a biology teacher taught a black and white photography class and I learned to develop my first roll of film. But most of my photographic knowledge was the result of reading the *TIME-LIFE* series of books. In particular, I studied the edition on darkroom processes.

In 1974, I kept up my black and white processing in a darkroom at the University of Washington's Department of Communication. There was a magic in seeing the film for the first time out of the wash, holding the frames up to the light to see what I had captured on film.

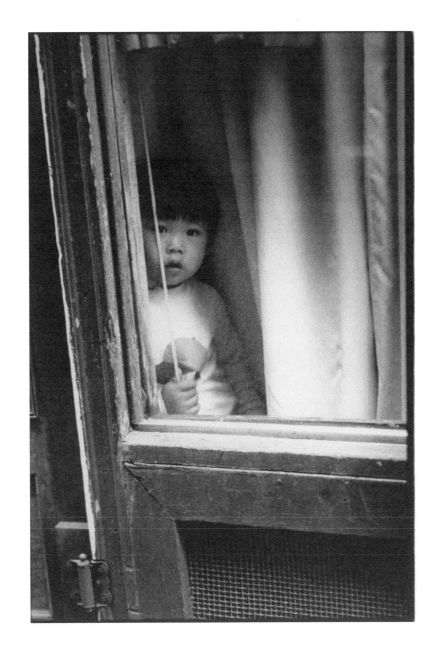

Boy in Canton Alley. SEATTLE 1991

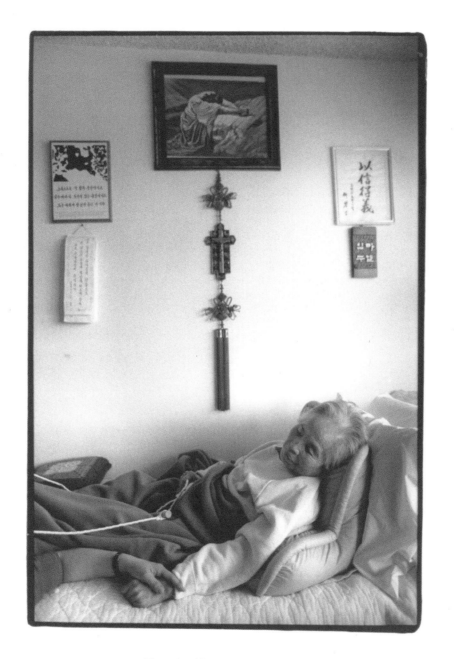

Kawabe House. SEATTLE 1993

A picture of an African musician beating a drum would catch someone's eye and earned me my first compliment. It was also my first published photograph, appearing in the *The Daily* at UW. I walked into a classroom with that print and someone recognized it. "You took that? That's a pretty good photo," she said.

Each week I would show my black and white contact sheets to Jean and she would critique them, offering constructive advice on how I could improve my compositions. She would study each frame and suggest ways to do it better. That was when I first learned the rule of thirds and how to use a fast enough shutter speed to avoid camera shake.

I had been a quiet, shy student at Cleveland High School on Beacon Hill who was not accepted by the popular Asian cliques. I was a withdrawn high schooler with only a few close friends.

At the University of Washington, I grew out of my shell and become involved in the Asian Student Coalition. I came in as a shy freshman and transformed myself into a student activist with shoulder length hair, a stylish green leather jacket and a pair of nunchucks in my book bag next to a copy of the Black Panthers newspaper.

As a student activist, I upheld the value of working in the community and standing up for the rights of minority people.

The Asian Student Coalition organized a street fair in Chinatown each spring as a way to give back to the community. Asian American students joined other students of color to support Joe Brazil, an African American jazz professor fighting to gain tenure and protested the Seattle Police Department's decision to use hollow-point bullets. When some Chicano faculty were dismissed, I joined thousands of students in protest in Red Square.

In the Department of Communication, I was inspired by Art France, an African American professor who would become a mentor. He inspired minority students to start our own newspaper called *Northwest Access.* He encouraged us to use our media skills to help our communities.

I met Ron Chew at *The Daily.* Ron would later end up as the editor of the *International Examiner* in Chinatown. Ron pulled me in as a volunteer helping to deliver stacks of *Examiner* newspapers to stores and restaurants in the neighborhood, which had now been renamed the International District by the city to reflect its diversity.

This was the beginning of my long association with Ron and the *Examiner* as a photographer and later as an editor and writer. Community journalism helped me grow as a photographer and then helped me develop as a writer.

I was not new to the Chinatown-International District, having grown up there and getting my first taste of community service years earlier with the International District Emergency Center (IDEC), a grassroots organization dedicated to helping Chinatown residents.

IDEC was Donnie Chin's vision to serve the community by providing first aid services to the people. I helped him set up shop in his grandfather's old Canton Alley storefront.

We became certified to teach CPR, borrowing dummies from the American Red Cross and teaching classes to Asian youth in the Chinatown Chamber of Commerce office. We responded to emergency calls in the International District and visited homebound seniors in their tiny apartments, often delivering canned food we had collected. Each day we would go on security patrols with clubs to keep the streets safe. If we saw people digging through dumpsters, we gave them food. It wasn't much, but it was something to eat.

The Seattle Police didn't know what to make of us at first. They'd drive their patrol cars through Canton Alley at night, shining their flashlights in the IDEC doorway before stopping to interrogate us.

IDEC ended up gaining the respect and support of Seattle Fire Department crews and Medic One paramedics who filled bags of first aid supplies to donate to us. The director of Medic One, Dr. Michael Copass, was a huge supporter, organizing an aluminum can recycling program with proceeds going to IDEC.

Eventually IDEC began providing aid stations at community events. It continues to do it to this day.

I started carrying my camera when I hung out at IDEC. In the early 1970s, Canton Alley was lined with old storefronts converted into housing for Chinese families. Children who grew up here would peer out their windows at us.

When my family moved to Beacon Hill, my brother Ed experimented with black and white processing in our downstairs bathroom. I ended up with his photo enlarger.

I left Seattle to work with San Francisco filmmaker Loni Ding in 1977. She had recruited me for the crew of her children's television series *Bean Sprouts,* which would later air on the Public Broadcasting Network.

Donnie Chin. SEATTLE 1984

When I moved to the Bay Area, I packed my car with the basics. My mother gave me a stack of freshly pressed shirts for my journey. Going with me on this California adventure was a brand new Nikon with thirty-five 2.8 and eighty-five 1.8 lenses.

Loni urged me to use my media skills to document Chinese America, just like Art France inspired me to. She hooked me up with a small group of journalists who published the *San Francisco Journal,* a weekly, volunteer-run newspaper with zero advertising.

I'd shoot photographs then go to their small office on Sunday nights to process the film. The older women at the *Journal* would look at my long hair, green leather jacket and matching green platform shoes, and then begin talking in hushed Cantonese voices. I spoke Toishan, so I didn't understand. They found me, an American-born Chinese from far north, to be a curiosity. I was a rebel in a sense, but I don't ever recall my mother complaining about the length of my hair.

Moving to California was a dream of mine. It was what the Beach Boys were singing about in "California Dreaming." The hippie movement intrigued me. I watched the anti-Vietnam war protests in Berkeley on television. Most important, I was drawn to San Francisco by its Chinatown.

Chinatown fascinated me to no end. I tried to photograph Chinatown, but my skills were not yet up to the task. My photographs only disappointed me. Subjects on the street would cover their faces when I raised the camera. I still had a lot to learn about street photography.

When I returned to Seattle three years later, I began taking photo assignments with the *International Examiner.* I photographed meetings, did portraits, went to community celebrations, and roamed the streets of Chinatown looking for anything that caught my eye.

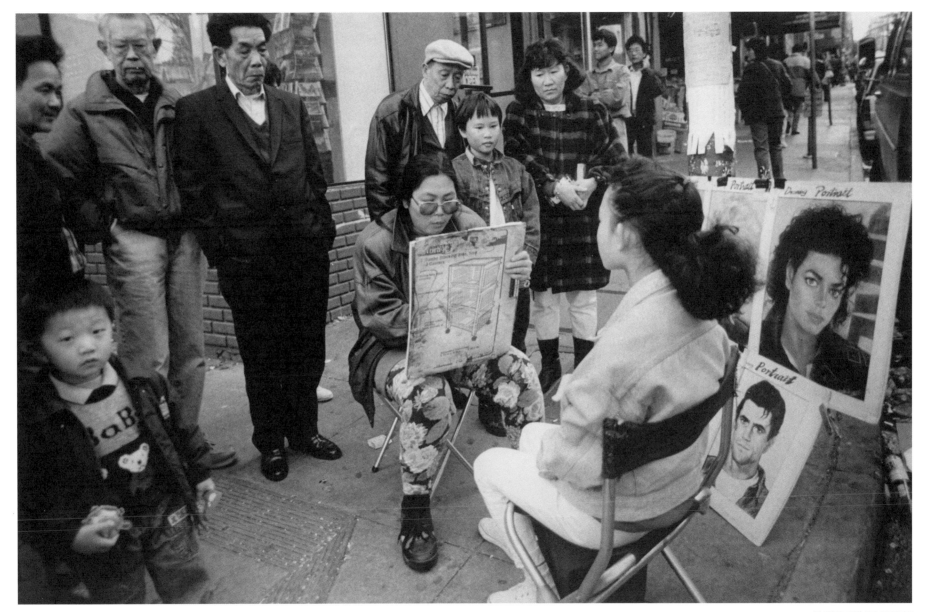

Street Artist. SAN FRANCISCO 1992

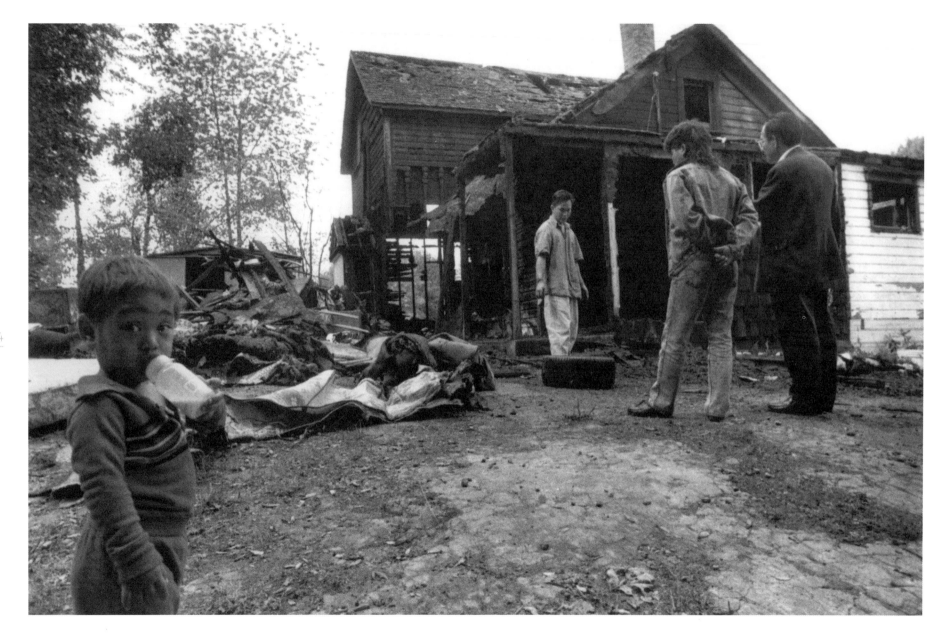

Beacon Hill Fire. SEATTLE 1996

I converted a walk-in closet in my mother's house into a darkroom. I still had a lot to learn about photography. My prints were flat in tone. At the time, I didn't know what a quality print looked like in terms of exposure and contrast. My sister Jean had left for art school in New York, so I had lost my photography mentor.

Gradually my photography improved. I began accumulating a body of work that I was confident in showing. This early body of work earned me my first recognition as an artist when the Seattle Arts Commission named me to the Seattle Artists 1991 program and I was awarded $7,500 to do as I wished. I chose to photograph San Francisco Chinatown.

When the *Examiner* joined the computer age, I took advantage and learned to write. I did it the hard way, struggling with a story about a fire on King Street. I struggled to come up with three paragraphs.

I learned journalism was not only about sitting at a typewriter. I learned to ask questions. Even taking notes had a learning curve. Information gathering was at the heart of reporting.

Eventually I found a voice with the written word and learned to tell stories in a compelling manner. I combined this newfound talent with my photography.

The early to mid-1990s were my most productive period at the *International Examiner* as I combined words and pictures. Editors like Danny Howe and Jeff Lin would clear out the middle pages to publish my feature stories with multiple photographs. Ryan Rhinehart wanted to tell me his story during his final battle against AIDS. He had stopped taking his medications. He wanted to tell me his life story and I was eager to listen. During his last days, he told me "I can't take it anymore. I'm ready to die. I'm not afraid."

Eun-Gyong Lee felt people treated her differently. She said the odds were stacked against her because she was a woman, short in stature, and was Korean. Blind from birth, she had never seen the world around her. Something most of us take for granted.

"Having all those things against [me] gets me upset," she said.

Dressed in his US Army uniform, Kaun Onodera and his fellow soldiers stood at the gate of the Minidoka Internment Camp where their Japanese American parents were forced to live behind barbed wire fences, their freedom stripped away. Guards treated Onodera as the enemy. "It was very galling to be in uniform, knowing there are our parents, still in camp. Perhaps there was a feeling of bitterness and anger," he said.

Someone once told me, "your writing shows you care about people."

I was touched by that statement. It defines my journalism efforts.

I'm fortunate to be living in such a vibrant place, full of culture and history. My life's work adds to this treasure we call community. The images and words I leave behind are my gift for future generations.

Seeing the Light: Four Decades in Chinatown is my legacy.

Canton Alley #6. SEATTLE 1976

2

A

PLACE

Encounter. SEATTLE 1992

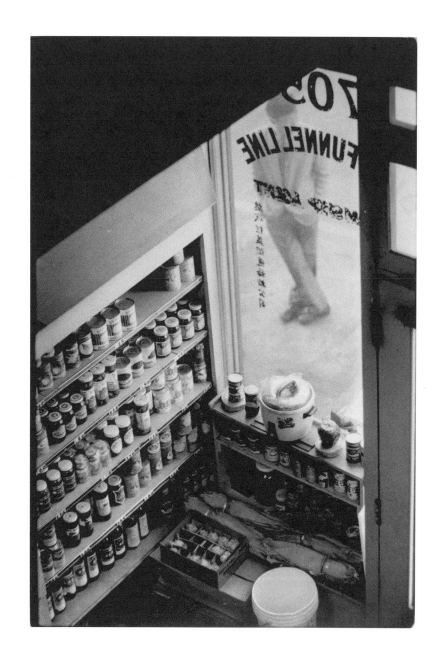

Blue Funnel Line. YICK FUNG COMPANY, SEATTLE 1991

In 1910, a group of Chinese pioneers in Seattle formed the Kong Yick Investment Company with the goal of erecting two buildings. Goon Dip, a respected and successful Chinatown businessman, led the group. They found an area built on landfill, a few blocks east of the original Chinatown, which had burned down during the Great Seattle Fire of 1889.

"It became the core of the new Chinese community when it was built and remains the core of the Chinese community even today," said Ron Chew, then Director of the Wing Luke Asian Museum.

The buildings are home to five family associations, representing the Lees, Woos, Wongs, Chews, Jangs, Lews, Louies and Fongs. It's also where you can find the Luck Ngi Musical Club, the Kay Ying Senior Club and the Yick Fung Company, the oldest store in Chinatown. There are family run restaurants, groceries, and markets in these buildings which are carrying on a rich retail tradition. Close to my heart, the International District Emergency Center is based there. Today, the Kong Yick Invesment Company consists of one hundred shareholders, and is run by seven officers, all second-or third-generation descendants of the original group of men. Over the years, the shareholders have been approached about selling, but they have always decided it was important to keep the buildings in the community. The two buildings have continued to play a major role in the social history of China-town, even more than forty years after the area was renamed the International District.

As someone born and raised in Seattle's Chinatown, I have fond memories of a childhood spent hanging out in Canton Alley, in between both buildings. I wore out many shoes running up and down King Street, jumping on the metal doors in the sidewalk. I knew many of the merchants, some of whom are still there.

At night, I would walk past the Wong Family Association, helping my mother carry groceries back home after she worked all day in our laundry. I remember going into the Wong Family Association during holidays to eat. The women would be busy running around the kitchen, cooking food and barking orders in the Toishan dialect while men read Chinese newspapers. The tables would be covered with soy sauce chicken, barbecued meats and homemade chow mein. It was a feast, Chinese American style. On the walls of the association hung hundreds of pink ribbons. Each ribbon bore the name of a member of the Wong Family Association. The family association still plays a role in the Chinatown community. As holiday celebrations continue, mah-jongg remains a popular activity to pass the time.

YICK FUNG COMPANY KITCHEN, SEATTLE 1991

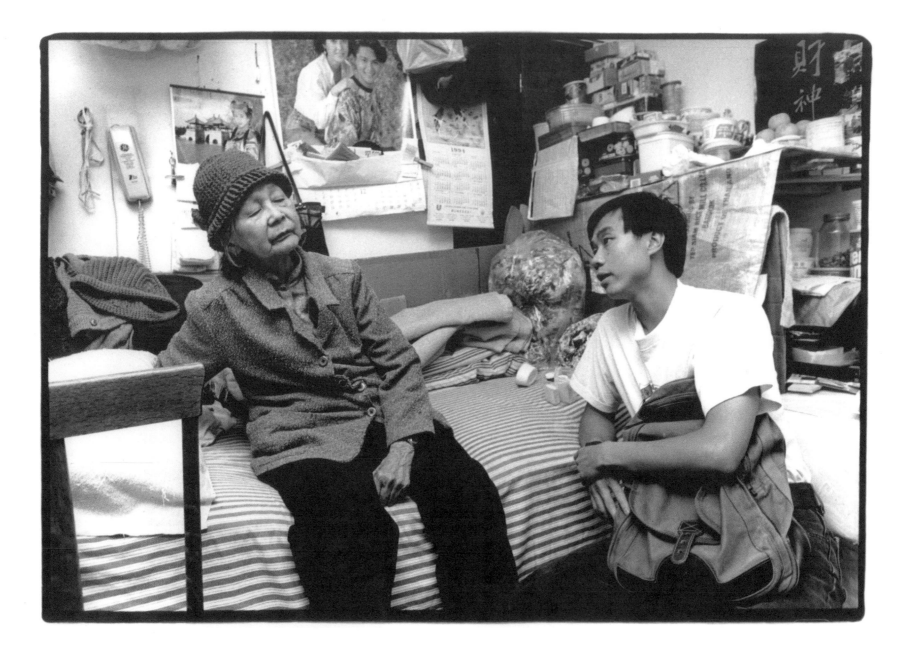

KONG YICK APARTMENTS, SEATTLE 1994

At one point, in 1994, the police claimed illegal gambling was taking place in the Wong Family Association, and in two other locations within those two half blocks. The police said they had names, witnesses, videotapes and evidence of individuals who had allegedly run an illegal gambling operation. The US Marshals posted notices of intent to seize the building. Eventually, the case against the Wong Family Association was dropped for lack of evidence, but the organization was forced to move out of the building as part of the agreement. The Wing Luke Asian Museum purchased the east Kong Yick building to build a brand new $24 million facility in the historic structure. The west Kong Yick building continues renting retail space to a variety of businesses and organizations. The Kong Yick Apartments on the second floor still offer low cost rent to Chinatown residents.

Still, for a time the entire community was threatened. And these buildings have too much history. Too much meaning. They're too important to a fading generation of the Chinese community, and to our future generations.

Epiginia Fernandez pushed the cart full of dirty towels and linen down the narrow hallway of the Bush Hotel on her way to room 342. "We have to clean the bathroom, the sink, change the linen, clean the television, the furniture, the blinds, and vacuum," said Epiginia, sixty-six years old when I talked to her in 1993.

Her husband, Jesus Fernandez, was a janitor in the building. Jesus was seventy when I met him. Every morning, armed with a broom and dustpan, he cleaned and swept the sidewalk in front of the building, years past its prime as one of Seattle's best hotels.

The couple had decided to retire after living and working at the Bush Hotel for the last seven years. They were scheduled to leave soon for San Diego to spend two months with three of their daughters. Then they'd return to the Philippines province of San Narcisco Zambales, where they'd met and married in a small wedding forty-eight years before.

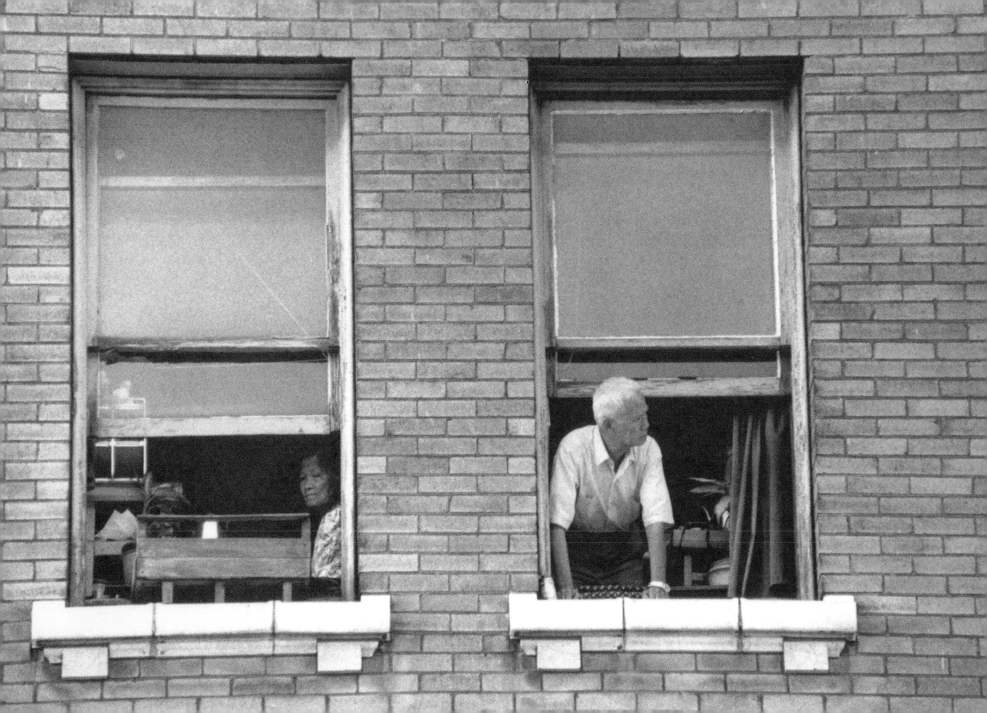

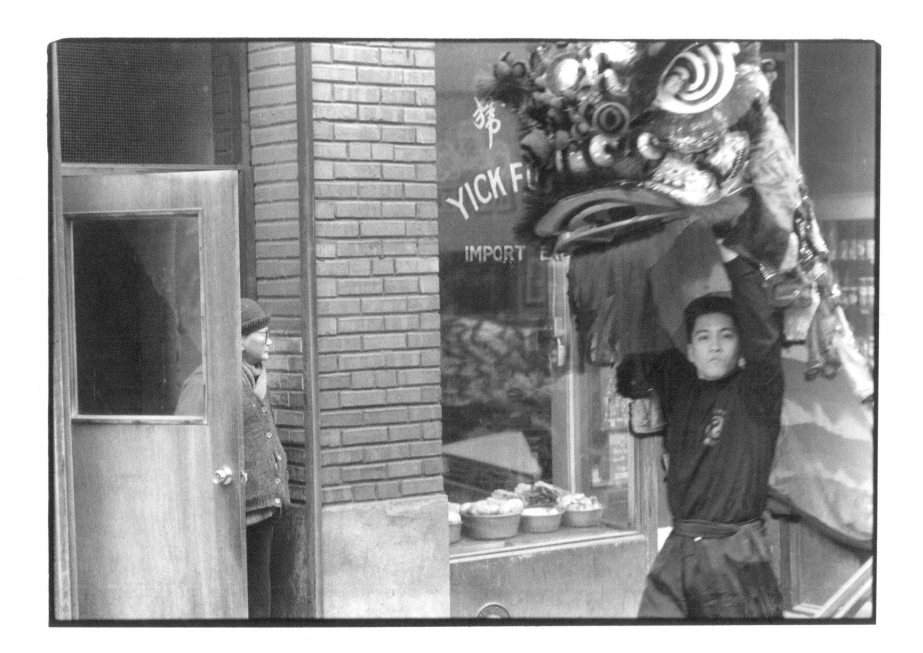

SEATTLE 1994

On a busy day, Epiginia would clean twenty rooms with a co-worker. On a slow day there would be eight to fifteen rooms. It would take Epiginia and a cleaning partner like Julita Ancheta thirty minutes to clean a room, depending on how dirty it was. "Some have bottles of beer, cigarette butts. Some residents are bad, they vomit in the sink or leave urine stains on the mattress," Epiginia said. Working as a team, Epiginia would push the vacuum and Julita would change the sheets.

"I like her very much. She's very understanding, a good companion for me," said Julita, herself seventy years old and living in the New Central Apartments down the street. Julita liked to sing as the pair went from room to room. "'Smile, till your heart is aching, smile.' You smile, so your work is light."

Everything in their cleaning arsenal was old, just like the hotel, which was built in 1916. "This building is older than me," Epiginia said. They had three brooms to work with. One was worn but usable. Another was bent and deformed; the end was rounded in the shape of a boxing glove. The third broom only had a few inches of bristles left. "These are the only brooms we have. Before I leave, I tell them to buy new brooms," Epiginia said. She looked at her watch. It was six minutes to four. The end of another day for the two maids.

"Do we look tired?" Epiginia asked.

"I don't feel tired, because I smile. I feel relaxed," Julita said.

The Bush Hotel basement had a rice cooker and other kitchen essentials for making a home-cooked Filipino meal. A favorite that Epiginia often made for the staff was a Filipino dish called sinigang, a soup of tamarind, vegetables, water, onion and garlic.

Epiginia said she would miss living at the Bush. "I like Chinatown because when you go downstairs, you can buy everything you want." Occasionally, she and Jesus would visit the International District Drop-In Center to dance with other Filipino seniors.

Two other recently-retired hotel staff joined the Fernandezes in a retirement party, where they all received bonuses. The next day, Jesus was seen cleaning his boss's office, picking up trash and placing it into a plastic bag. Upstairs, for one last day, Epiginia pushed the cart down the hallway, the same way she had done for the past seven years.

For Epiginia and Jesus, retirement wouldn't begin for another day.

At the Evergreen Washelli Cemetery, clumps of dried grass rest beside the headstones bearing the names of soldiers who fought under the banner of the 100th/442nd Regimental Combat Team (RCT) during World War II. The names are all Nisei, second-generation Japanese Americans. They were young when they joined, most between the ages of eighteen and twenty-one. Recruiters visited Minidoka Internment Camp in Hunt, Idaho, looking for young men willing to volunteer for an all-Japanese combat outfit. In 1993, I talked to surviving veterans like Kaun Onodera, then in their seventies. Onodera's father had supported his son's decision to enlist.

"It was for American citizenship, duty, honor and all those things," he said. "[I and most of the guys I knew] volunteered for the same purpose, even though we were in concentration camps," said Onodera. The people in the camp were mainly from western Washington.

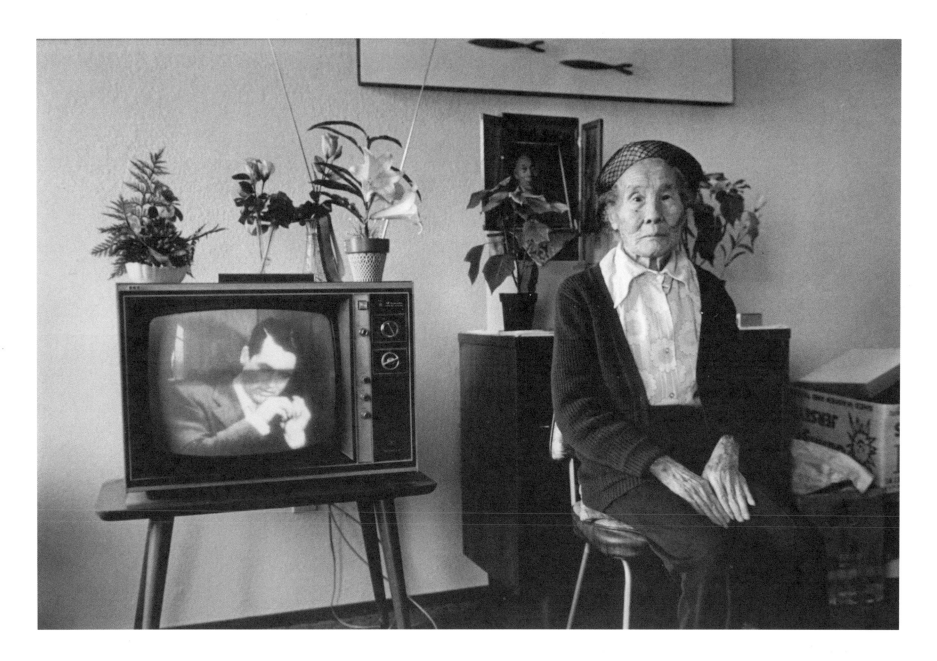

Nisei Woman. SEATTLE 1994

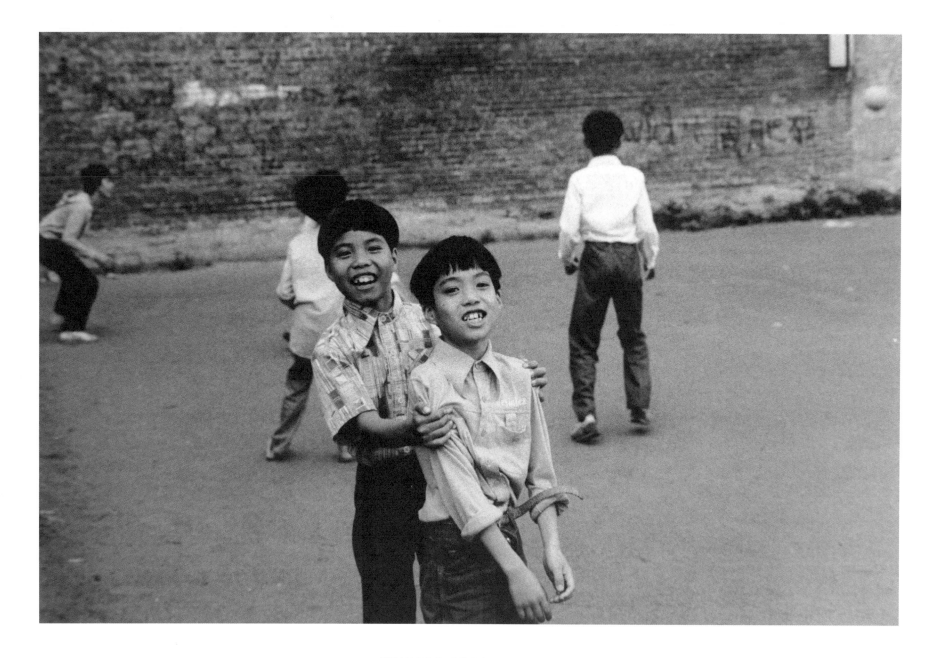

32

CHONG WA PLAYFIELD, SEATTLE 1982

Kaun and his two brothers—Satoru, three years younger, and Ko, two years his elder—had all enlisted in the Army. Ko did not see action. Kaun fought with the 442nd in a mortar unit, as a runner, wearing a vest loaded with shells. Satoru was assigned to a 442nd Infantry unit as a rifleman. He was killed on July 7, 1944, during a firefight in Italy. He was awarded the Purple Heart posthumously.

While in basic training, Kaun had visited Minidoka. Even though he was in uniform, the guards made it difficult for him to get in and out of camp. The guards considered all Japanese the enemy, even those wearing US Army uniforms.

Veteran George K. Sato volunteered out of Minidoka. His father was upset at his decision, arguing, "Why volunteer when the government put you in a place like this?"

Sato felt strongly about volunteering right out of internment camp. He was willing to serve his country and possibly die. "Volunteering is something that became a strong word." Sato remembers what many of the mothers in camp told their sons before leaving to fight in the war: "Live if you can. Die if you must. But don't bring shame to the country." Sato fought back tears as he spoke. Sato came back with several medals, but downplayed the significance of it "It's important to remember we got these on behalf of those guys who were killed. They made it possible for us to get back. Guys who did not come back should get a medal."

"I'm a volunteer. I'm Rembrandt Michaelangelo," seventy-one-year-old Jack Pang joked in 1993 as he discussed a scene he was painting at the Cathay Post memorial. In 1950, the Post built a memorial in the Chong Wa playfield as a permanent reminder of the men who did not come back from World War II. In 1987, they decided to move the memorial to Hing Hay Park where more people could see it. For over seventy years, the men of Cathay Post #186 of the American Legion carried on a Memorial Day tradition honoring ten Chinese American soldiers who died during the war. Each year, the ceremony gathered a small crowd of onlookers as the veterans observed the holiday by laying flowers at the base of the memorial.

Most of the young Chinese men in the early 1940s were drafted into service. "We all went in at separate times into different branches like the Navy, the Coast Guard and the Army," said Pang, who went into the Air Force. After the war, Pang realized his friends, like himself, were all just Chinese Americans. Although Pang attended Chinese School, he had grown up outside of Chinatown near 34th Avenue and James Street and he used to tease the other kids who lived in Chinatown when he visited. "I was an uptown guy. I called them Chinatown rats," Pang said, referring to the fact that many of his friends lived in places like Canton and Maynard alleys.

FACING: Howard Mar. YICK FUNG COMPANY, SEATTLE 1993

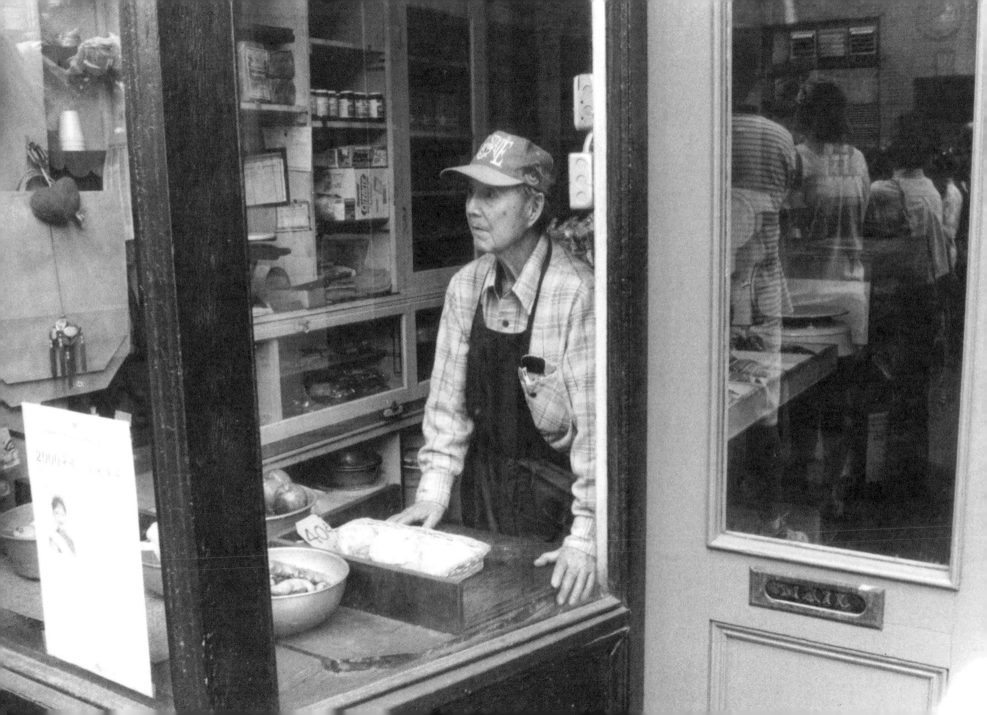

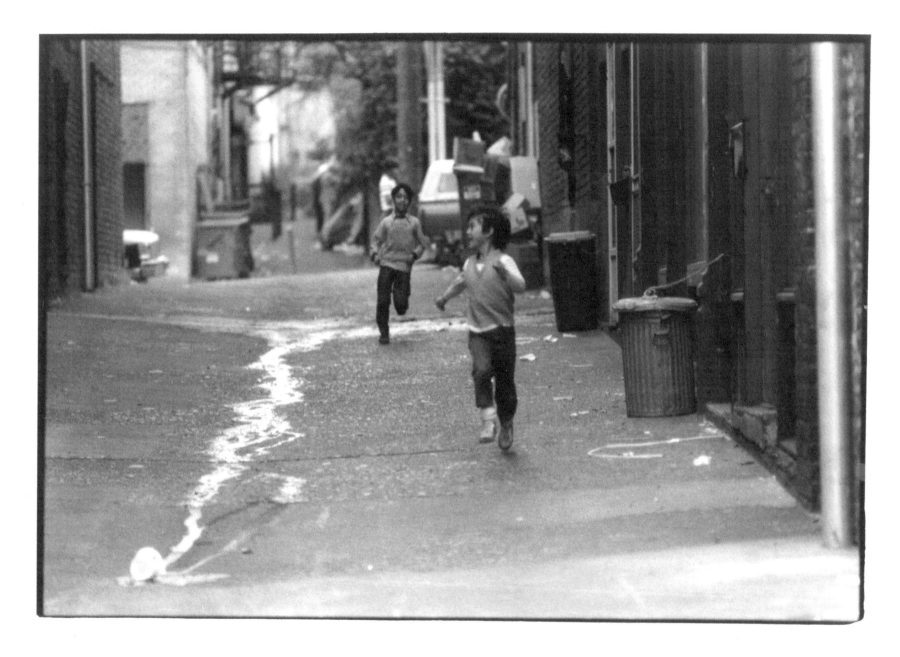

Lap "Baby" Woo. CANTON ALLEY. SEATTLE 1983

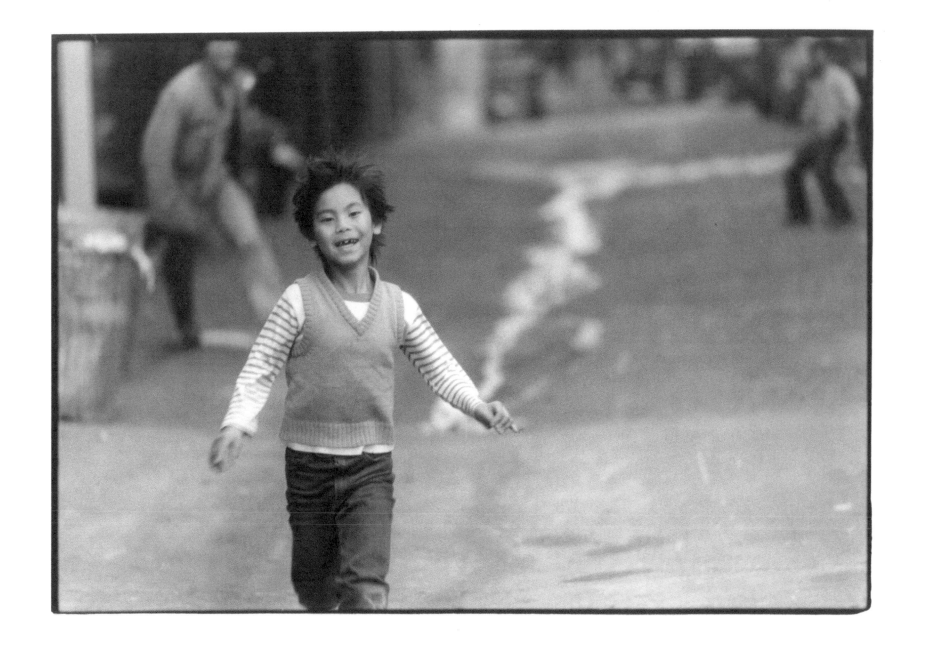

I told Pang that I used to climb the memorial to get over a fence to retrieve baseballs when I was just a kid.

"You have a history too. You'd better document those pranks," Pang replied.

I then told him my friends and I put firecrackers in the same wall where the mural was being painted.

"No wonder there are all these holes," said then sixty-eight-year-old Raymond Lew, another Cathay Post veteran, as he smiled and placed his fingers in holes too large to have been caused by small firecrackers. Lew and Pang go way back. They attended Chinese school together and often got into trouble for climbing out the windows, instead of exiting through the doors. Lew was drafted into the US Army in 1943 and sent to Hawaii for basic training.

Pang says his generation took things for granted when they were young. "Now that we're a little older, we realize that, heck, a lot of things we did and saw are being lost."

As the years passed, the ceremony changed, but the Memorial Day ritual kept the Cathay Post veterans going each year they aged. "We don't talk too much about the wars we served in, although that's what bonds us together: the comradeship, the sense of belonging to an organization," said Lew. He hopes to pass on the stories of the Cathay Post and the ten men whose names are engraved on the stone. "The kids that come around, I hope they ask what the purpose of this is," he said.

That day in 1993, Pang climbed the stairs of Chong Wa, the same stairs he once played on as a child. Pang was looking for an American flag, so he could see how the stars would be arranged for his painting. He counted the stars and walked back to the playfield to prepare some white paint.

FACING: PUGET SOUND HOTEL, SEATTLE 1992

3

SAN FRANCISCO 1992

Photos taken during this trip to San Francisco in 1992 were funded by the Seattle Arts Commission.

Uncle's Cafe window.

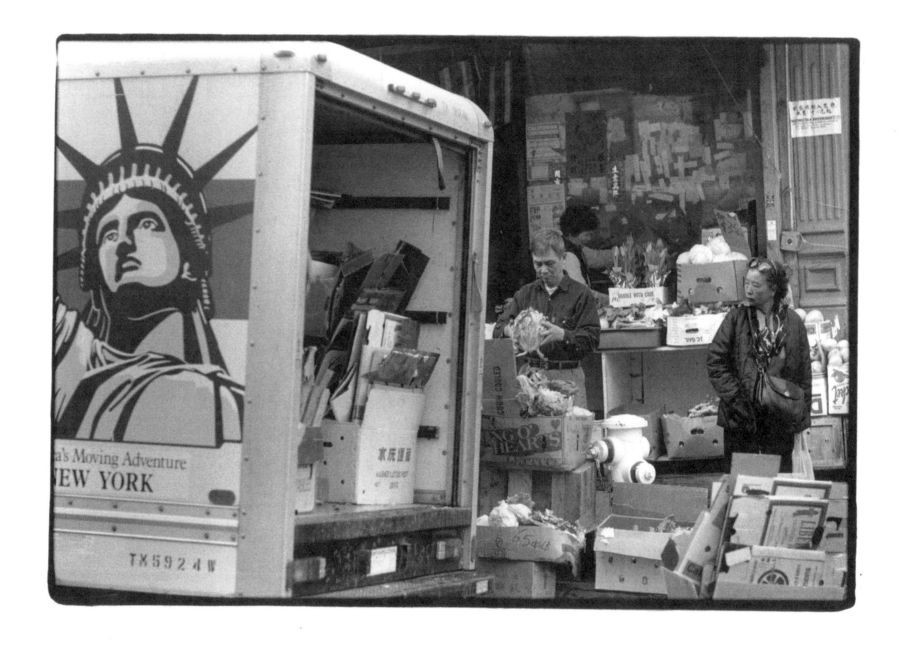

Saturday, February 1

There was a sense of urgency in Chinatown with the Chinese New Year being celebrated the next day. Shoppers were busy on Stockton Street where businesses sell everything from clothing to live birds, produce, meat, groceries, Chinese herbs, and State of California Lotto tickets.

Street vendors lined both sides of the sidewalk. Some operated out of trucks and vans, arriving early in the morning to claim a valuable parking space. Some of the stalls completely obscured parking meters and fire hydrants with their boxes of oranges, produce, magazines, Chinese music cassettes, flowers, red envelopes, and bright red New Year's banners. The street vendors added to an already crowded sidewalk, causing human gridlock as shoppers pressed against one another. There were several busy bus stops on Stockton Street. Riders waited while young boys held up signs in Chinese which read, "Please wait in line. Watch out for pickpockets." The boys helped bring order to the lines of people waiting for the bus. The signs also encouraged riders to line up in an orderly fashion to provide room for pedestrians.

While Stockton served the needs of local residents, Grant Avenue was where you found the gift shops catering to tourists. In front of a bank, an elderly Chinese man sat on a stool playing an *erhu*, a Chinese stringed instrument. A cassette player taped to his knee provided music to accompany his street performance. Inside a case stretched out in front of him was a single dollar bill neatly tucked into a pocket next to a digital stopwatch. I slipped four dollar bills into his case. His face lit up.

"Where are you from?" he asked. Surely a man with a camera was not a local.

I told him Seattle. He'd heard of the city. There were more questions, but I was having trouble understanding him. My basic Toishan was failing me, or he was speaking another dialect altogether.

He wanted to know if anyone in Seattle played Chinese music. I told him we had a Chinese music club, but no one played in the street like he did.

As his right hand moved the bow across the strings, people walked past, hardly noticing. Only a few tourists offered money after snapping some pictures.

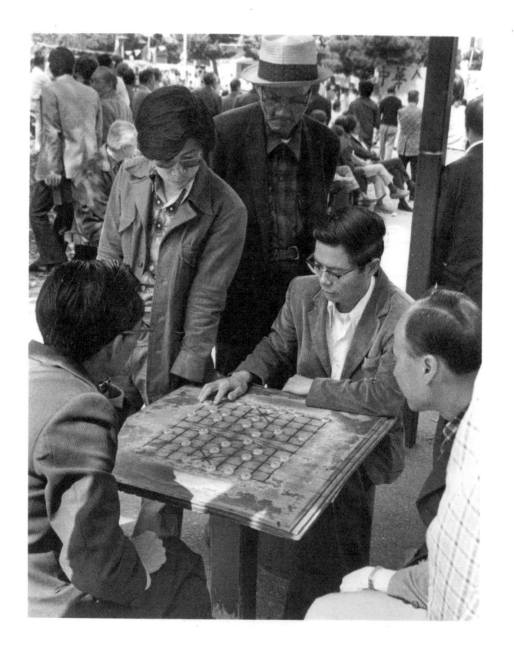

PORTSMOUTH SQUARE 1978

Each morning at 8 a.m., I sat in the window of a restaurant called Uncle's Café, famous for its apple pie. I placed my camera, attached with a wide-angle lens, on the windowsill. Each time someone passed by, I pressed the shutter.

Chinatown is a top tourist destination in San Francisco, along with the Golden Gate Bridge, Fisherman's Wharf, the cable cars, and crooked Lombard Street. My project to photograph Chinatown was funded by a Seattle Arts Commission grant. One of my objectives was to think more freely as a photographer. My plan was shoot photographs without using the viewfinder.

A woman walked by with her hands behind her, clutching a shopping bag. The windows were fogged, adding a sense of mystery to the image. Moments later a girl stopped in front of the window, a violin case in her arms. Life went on, that morning on Waverly Avenue in front of Uncle's Café. It was still early. There was very little traffic on the street. The only sound I heard was a voice. "Spare a quarter, spare a quarter."

Across the street in front of the China Trade Center, a woman was standing under a lamppost. Her hands, covered by orange mittens, moved up and down in rhythm with her chanting. This was the same woman I had seen near the Stockton Street Tunnel the day before and panhandling upscale Union Square shoppers a few days earlier. When she wasn't begging, she sat in the children's area of Portsmouth Square, talking to herself and cursing to no one in particular.

Chinatown residents came to Portsmouth Square to hang out and escape the stale air of their cramped one-room apartments. Some sat on the benches socializing or reading Chinese newspapers. Others gathered around several tables where people gambled all day, starting at the crack of dawn. Some were playing Chinese checkers, but others looked like they were playing poker or some kind of card game with money being displayed. Occasionally, a policeman walked among the crowd but did nothing.

A man in a worn suit told me about a gambling raid in Portsmouth Square that had happened recently. The police had raided one game and confiscated a hundred thousand dollars in cash. Six of the men who were arrested were armed and wearing bullet-proof vests. He told me the old street gangs of the 1960s and early 1970s like the Wah Ching and Joe Boys were phasing out. Many gang members had gotten older and were starting families.

When I had moved to San Francisco in 1977, I arrived the night of the Golden Dragon Massacre inside the Golden Dragon Restaurant. Five innocent people were killed as the Joe Boys and Wah Ching shot it out.

The new gangs that I heard about in 1992 were linked to the triads, the man told me. "They make the Wah Ching and the Joe Boys look like shit," he said.

47

It was the Chinese New Year of the Monkey.

Chinatown was just waking up and the sounds of firecrackers were already echoing off the walls of those old buildings.

The sidewalks were covered in red paper, remnants of firecrackers exploded at midnight the night before to welcome in the New Year. Incense could be seen burning on the balconies of the tongs and family associations.

Shortly before noon, I spotted Y.C. Wong's Lion Dance Team setting up on Pacific and Grant. They were getting ready to perform for a Chinese bank. The employees were piecing together strings with lettuce and paper money as an offering to the lion. The lion woke up to the sound of the drums and cymbal. A crowd gathered on the street, blocking the traffic. Two lions pranced around exploding firecrackers while a man in a mask teased them with a fan. Several stands, like saw horses, made with pieces of two by four wood painted bright red, were set up on the street. The lion climbed on the structure and balanced on top. It made subtle movements with its head, eyes and ears, mimicking a real animal.

When it came time to accept the offering from the bank, the lions couldn't reach. The money was hung too high. Y.C. took over on the drums. As soon as he did, the sound of the drum intensified. The young man in one of the lion heads leapt onto the thighs of the person in the tail, then onto his shoulders. In perfect control, he grabbed the head of lettuce and brought the string of money down.

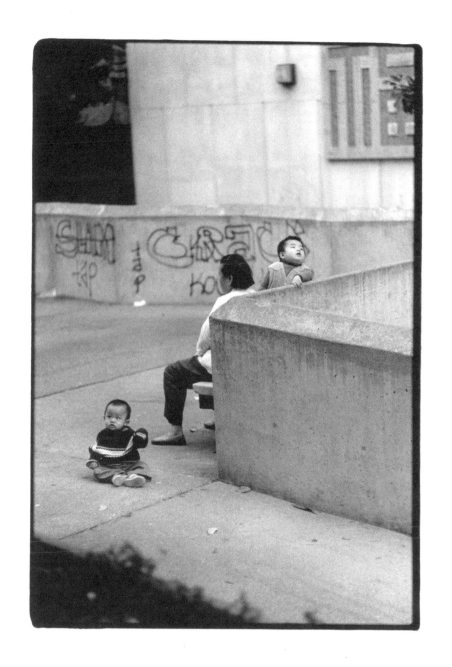

I entered the Sam Wo Restaurant by walking through the tiny kitchen, passing some men chopping meat and vegetables on worn-out cutting boards. It was the type of steamy-hot kitchen that gave a sense of history to this neighborhood. You could imagine the long hours men and women worked in China-town to make ends meet. Somehow the American dream—Gold Mountain—became in reality a twelve-hour day with sweat rolling down their foreheads and aching feet.

I climbed the winding stairs leading to the third floor where there were nine old tables, wooden stools and a balcony overlooking Washington Street. A woman greeted me by saying, "Gung Hay Fat Choy." She was sitting at a table with a co-worker, folding and filling wonton wrappers with meat. She scooped up a small clump of pork, water chestnut and shrimp with a butter knife and placed it on the wonton skin wraps, her fingers forming small pleats. Above her was a faded Miss Chinatown USA poster, illuminated by some bare lightbulbs. Behind her was a narrow door, leading to the kind of bathroom visitors to Chinese restaurants were wise to avoid.

"I've worked here over twenty years, making wontons and running the third floor," the woman told me. A little English was mixed in with her Chinese. "This restaurant is over one hundred years old."

I told her I had come here with my brother when I was a teenager. He had promised Sam Wo Restau-rant was a famous "hole in the wall" and he had been right.

She reached into a shelf and pulled out a tattered manila envelope. She pulled out a drawing of the late Edsel Ford Fung who used to be the waiter on the now-vacant second floor. "He was a very loud man," she said. She handed me a Xerox copy of a page from a tourist guide to San Francisco. The book described Fung as "The World's Rudest Waiter."

I took out a small portfolio I'd been carrying around in my camera bag. A picture of three women in my mother's laundry caught their eye.

"My mother ran this laundry thirty-five years," I told her.

Then I showed an image of a Chinese American soldier being greeted by his family after returning from the Persian Gulf War in 1991. He's in a daze as one sister cries uncontrollably and another is overcome with joy.

A new customer arrived for a bowl of Sam Wo noodles. He was Italian, with long hair and a black motorcycle jacket. He looked like rock star Alice Cooper and told me he had lived in San Francisco all his life. He overheard some of my conversations with the two women and told me: "The Chinese need better housing. The housing here is too old. All the politicians say they'll give the Chinese better housing. But when they're in office, nothing happens." The man said that Tom Hsieh had run for mayor and although there were a lot of Chinese in San Francisco, he would never get elected. "It's because of racism," he told me.

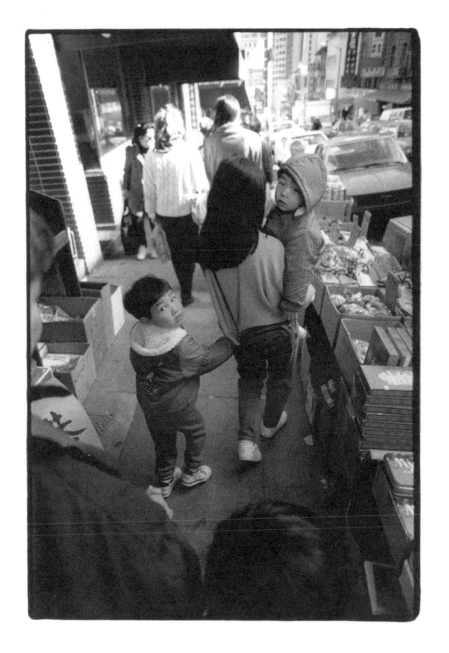

It was 9:30 a.m. My last day in San Francisco. I took one last walk through Portsmouth Square. The men at the tables were looking over their cards. Some of the elderly were already sitting on the benches, reading or preparing to do their tai chi exercises. The sounds of firecrackers could still be heard every few minutes.

Most of the people I'd spoken to in the last week didn't seem to understand my Toishan dialect. Sometimes they'd ask me if I was Chinese after I'd say something, then give me a puzzled look. Some of these people had lived in Chinatown all their lives and had not learned English. They were in a world all their own.

Over one hundred years before, angry mobs had kicked the Chinese out of their cities up and down the West Coast. When the Chinese first came to San Francisco, a man named Sandlot Kearny used to stand where Portsmouth Square is now, and give speeches on why the Chinamen should be driven out of town. When I visited in 1992, the Chinese American population in San Francisco was one hundred thousand strong. The Chinese are here to stay.

Before making my way back to the hotel to board my airport shuttle, I stopped at the Chinatown McDonald's for coffee. I sat there reading *Longtime Californ': A Documentary Study of an American Chinatown* by Victor and Brett De Bary Nee.

I walked through the Chinatown Gate on Grant Avenue and headed towards Union Square. There was an empty feeling. Like I was leaving a part of me behind. A part of me I wanted to know more about.

53

4

A
PEOPLE

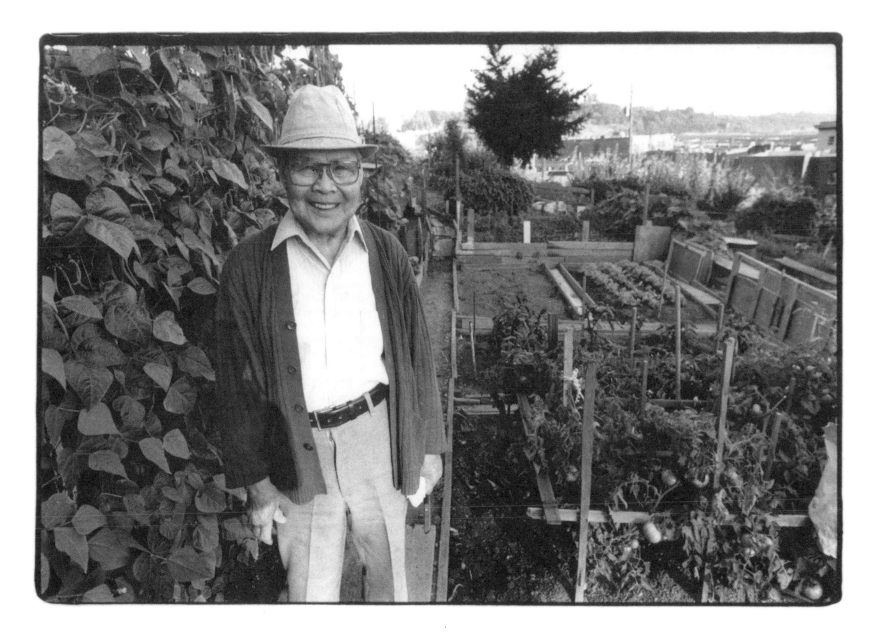

Felipe Vides. DANNY WOO COMMUNITY GARDEN, SEATTLE 1992

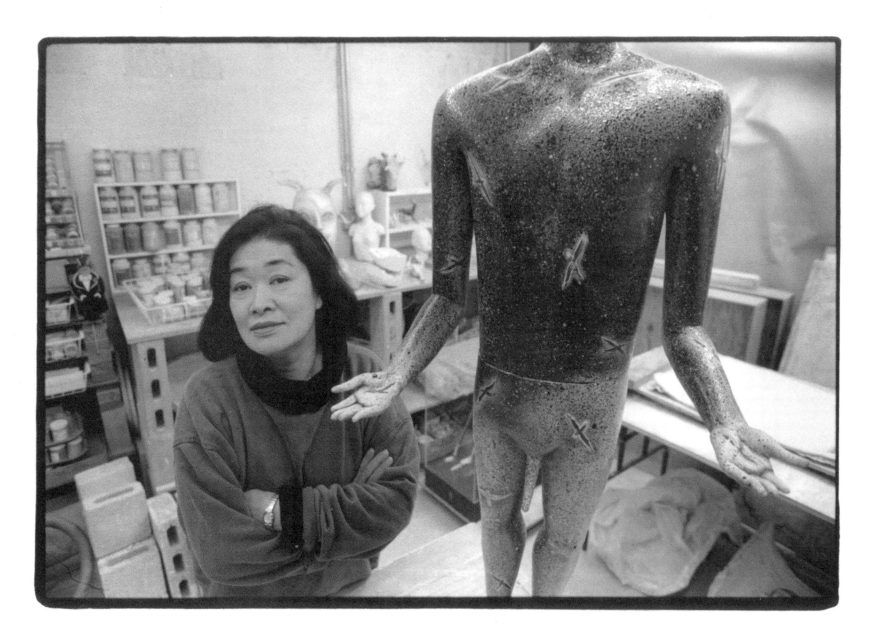

Patty Warashina. SEATTLE 1991

With a little imagination, artist Meng Huang took the things people had thrown away and turned them into sculptures. Huang went out to dig through garbage dumpsters nearly every day. As an artist, he was so prolific, his Chinatown apartment filled wall to wall with his creations.

"Each day, there is more stuff," Huang said. When I talked to him in 1993, the seventy-year-old was standing in a narrow pathway winding through the living room and kitchen to the bedroom.

The Jackson Apartment, where Huang lived, was managed by the Seattle Chinatown-International District Preservation and Development Authority (PDA). The building's tenants fall under Housing and Urban Development (HUD) regulations because the apartments are for Section 8 low-income tenants. A HUD inspection had found Huang's apartment as having an "extreme storage problem." When I met him, Huang was worried he might be evicted.

Norberto Ilagan, a residential manager for the PDA, said he had encouraged Huang to remove things little by little. "It's ok, if he wants to leave some as long as it's not too crowded."

The PDA was discussing a way to help Huang clean out unused items in his apartment while keeping the art he had made.

The walls in his apartment were covered with masks he had created from plastic garbage can lids, Big Mac containers, and other objects. He liked plastic items for their color.

Huang had made a duck from a toy fire fighter's helmet. A beer can was attached to the end, with plastic cup lids and blue film container tops forming the eyes. The head was a blue upside-down plastic cup. Another red plastic cup, cut and flattened into a "V" shape, formed the duck's face. A small orange nipple represented the nose.

Scattered throughout his one bedroom apartment were other, more elaborate toys that were more like sculpted art, such as a weed eater Huang turned into a dragon.

"I try to recycle everything. Give it new life," he said. "I walk around to get exercise. I look for things." When he picked through a garbage can, Huang wanted to use everything he found. "People waste things, they throw things away. Nobody knows what I mean. To anyone else, they see trash. It's not. I've created something out of junk," Huang said.

SEATTLE 1992

DANNY WOO COMMUNITY GARDEN, SEATTLE, 1995

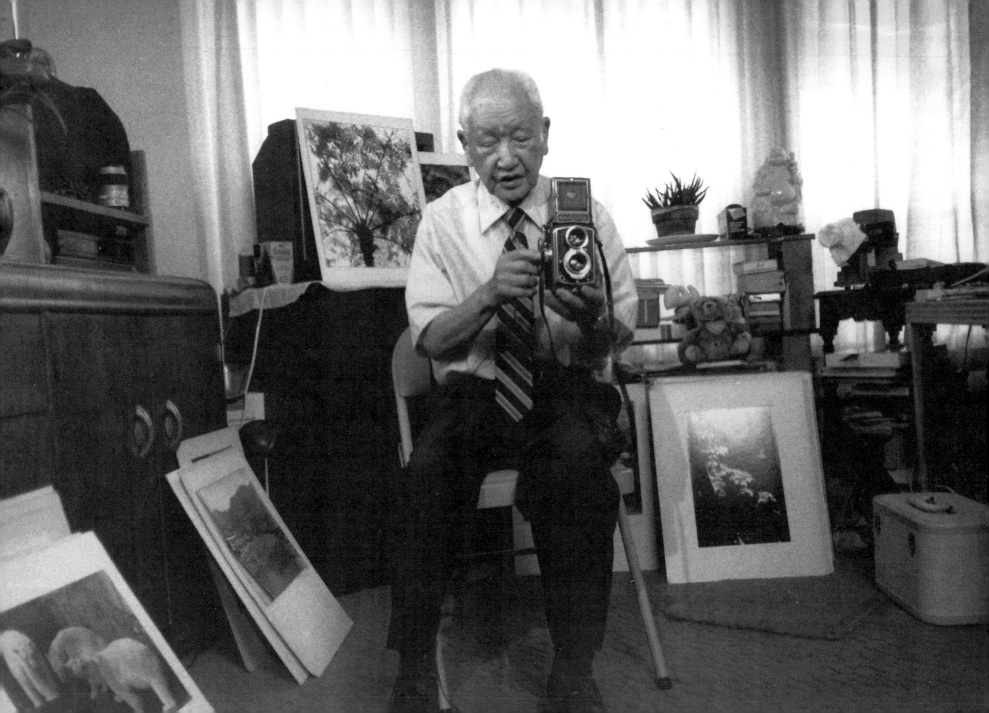

Holding his favorite camera and surrounded by a lifetime of photographs, Henry Takayoshi said, "Before I close my eyes, I would like to show my pictures."

It was a Sunday morning in September 1992. A group of us from the Wing Luke Asian Museum placed Takayoshi, ninety-four years old, in a chair in the middle of the room, surrounded by his cameras and his pictures, all neatly mounted on matboard. Although he was very alert, his eyes remained closed much of the time.

Speaking in Japanese, through a translator, Takayoshi said he was born in Shimane Prefecture, Japan in 1899. In 1916, he moved to Bainbridge Island to live with his father, who ran a greenhouse. That same year, he got his first toy camera. He enjoyed the solitude of taking pictures by himself. Living in an isolated place, away from his friends, he found photography relaxing.

His father grew crops such as tomatoes, often traveling to Seattle on selling trips, but the business was not that profitable. His parents were so busy just trying to make ends meet. It was difficult, Takayoshi said. "I wondered each day where the next meal was coming from."

One day Henry saw a beautiful picture on a table. It was then that he decided his toy camera was not good enough. He wanted a real camera and thought about quitting school to work in a sawmill to buy one. His father said no, but finally gave in and bought one. The camera cost ninety-five dollars. He began taking a lot of nature photos. Why nature pictures? "Whenever I took pictures of people, they always complain they look skinny."

As a young man, Takayoshi was sent to Manzanar Internment Camp. The only photographic item they let him take to camp was a tripod. But Henry hid his camera in a case. "I was supposed to have left the camera in a church and it ended up in Manzanar," he said.

Around 1927, a friend who was going back to Japan told him. "Isn't it about time you had a wife?" His friend asked for a picture of Takayoshi to take back to Japan. So he took a picture of himself in front of his house.

In Japan, Takayoshi's future wife Kikuyo looked at the photo. "He looked so handsome. Like the ideal husband," Kikuyo recalled, as she sat next to him, holding a black and white image of them together.

Takayoshi met Kikuyo when she came to the United States. He was busy trying to wash his face when she walked in the room. They were married three days later.

After the war, Takayoshi continued to do photography as a hobby. He eventually got a job in a store selling cameras and film. Whenever he had some good pictures, he would send them to competitions. On the back of his winning photographs are labels from contests and exhibitions he took part in.

"Once in a while, all my pictures came back. They did not make the entry," Takayoshi said.

But sometimes the photos were very good, such as the one he titled *Geta*, showing three sandals on a wooden floor. "This picture, I took in Japan. I think it's good. Shows all the grain in wood. But judge may not like it."

On a table, Takayoshi displays two of his favorite cameras, a Pentax Spotmatic and a Nikkormat EL. His most cherished camera, is a Rollicord, twin lens reflex. "When I came back from Japan, a robber came in and took all my cameras. I was terribly disappointed. I felt a tremendous loss," he said. "At the time, I worked at a camera shop. The owner asked me if I was sick. He patted me on the back and said 'look at all these cameras. Take the one you want.' I chose the Rollicord."

Friends have told Takayoshi he's obsessed with taking pictures. He must be crazy, with a camera hanging from his neck all the time, they told him.

"I take a picture when something strikes me. I can never tell what is going to be a good picture."

Is it intuition? "If I had that, I would not have all this hard time."

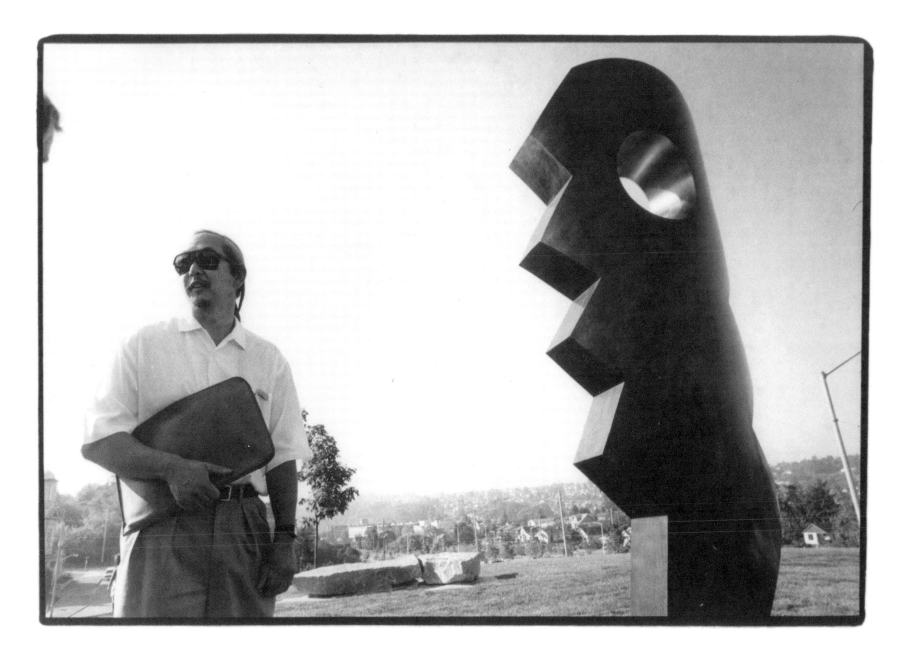

Gerard Tsutakawa. URBAN PEACE CIRCLE, SEATTLE 1994

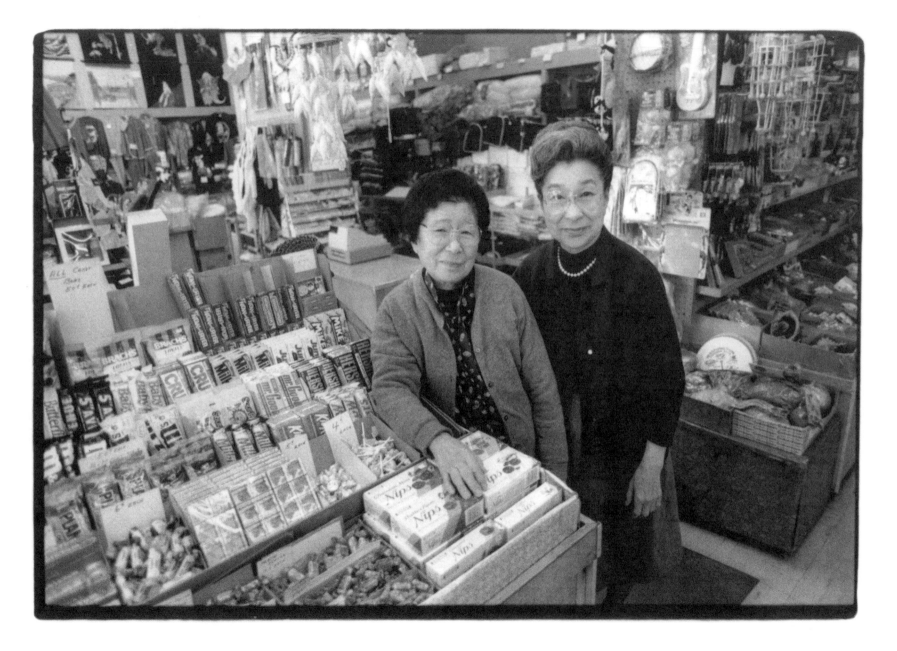

Aya (left) and Masa Murakami. HIGO VARIETY STORE, SEATTLE, 1993

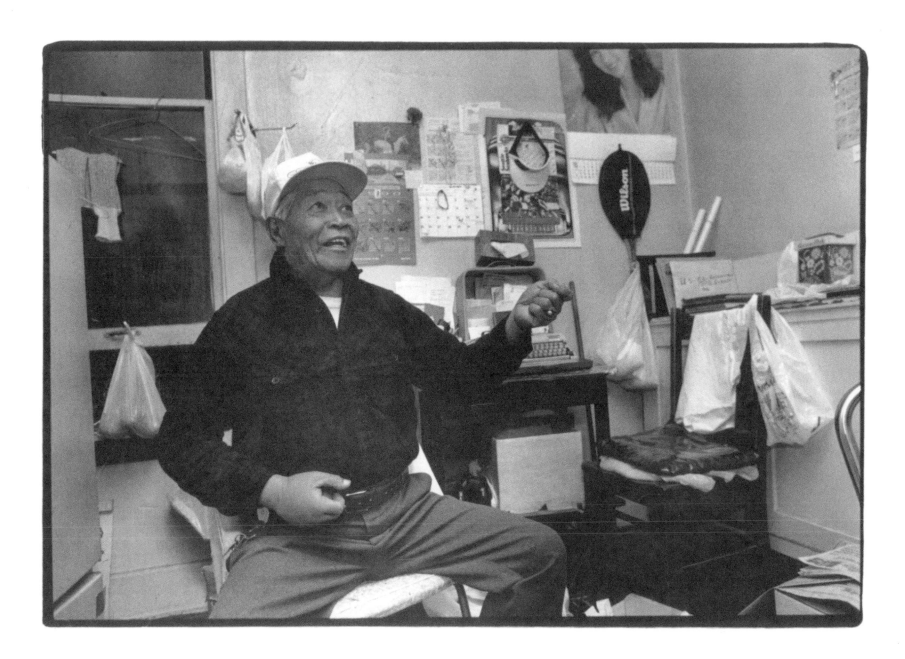

Aureo Bibat. EASTERN HOTEL, SEATTLE 1994

When I visited him one day in 1993, Ryan Rhinehart's room was dark. A small lamp illuminated a wall covered with pictures of Ryan with friends, most of them performers in drag. Memories of better days.

A voice called out from the bathroom. "Be out in a minute."

I sat on a couch near Ryan's bed and took a good look around his room at the Bailey Boushay House, a care facility for people with AIDS.

The bathroom door opened. A shaft of light swept across the blanket and pillow. Ryan came out, wearing only a diaper. He leapt into bed, like a little boy might do, then quickly pulled the sheets up around him. He didn't bother to extend his hand to me.

I had met Ryan a year earlier when he was diagnosed with AIDS. He looked older on the day of that visit; his skin was pale and he had lost significant weight. When he spoke, his voice was weaker.

Ryan was dying and he wanted to talk to me. He wanted people to know about AIDS. That it could happen to anyone. During the hour that I was with Ryan, he laid there on the bed, curled up in a fetal position, his blanket wrapped around him. His answers to my questions were short. I could sense that he was in pain. Several times during the interview he grimaced. I asked if he wanted to take a break, but he wanted to continue.

No longer eating solid food, Ryan had been taking something called TPN for nine months. "It has nutrients like food and chemicals which are supposed to help me," Ryan said. TPN came in an intravenous bag that hooked up to a tube entering his chest. At four hundred dollars a day, it was an expensive treatment. "I stopped taking all the pills and other stuff which helps me in certain ways. I couldn't handle it anymore. I needed a break. It was my decision. It was too overwhelming." By taking himself off drugs, Ryan had moved up his death by a month or two. "I want to get this over with," he said. "I want to die because there is so much stress involved. I'm ready to die. I'm not afraid."

Ryan Rhinehart. SEATTLE 1995

Eddie Moy. TAI TUNG RESTAURANT, SEATTLE 1992

Born in Korea, Ryan was adopted when he was three and a half. At seven, Ryan knew he was gay. "It's just something I realized. I was born that way. When I was a teenager, I left home and that was part of the reason." Ryan's parents were not supportive.

After leaving home he dealt with discrimination for being Korean and gay. He changed; he became more independent; he traveled.

Ryan found out he was HIV positive during Christmas 1991.

First there was denial, then shock. He didn't know who he'd gotten the virus from. "I moved around too much back then because I wanted to explore the world. It was a real shock because it got worse. I was real upset. I wasn't expecting it. We always think we're careful and it's not going to happen to us, but that's not the way it works." Ryan visited schools to educate young people about AIDS, but he had had a tough time getting the Asian community to talk about it.

I asked Ryan about the photographs on the wall behind him. The pictures were of drag stars. Men dressed up as women. Ryan was good at it. Ryan's stage name was Pineapple Princess. "The Pineapple is a fruit, not a vegetable. That's a joke." He enjoyed drag because he received a lot of recognition from it. "When you see me in person, you would think I'm a girl."

On a lamp table, a small pineapple pendant sat in a box—a gift from friends. There were several teddy bears on the table as well. One wore the crown Ryan received when he won a drag competition. He got to keep the crown for one year before it was turned over to the next "Queen of Hearts."

His favorite photographs were also on the table. There was a picture of him when he was eight years old. A black and white photograph I took of Ryan with his cat was neatly framed, though partly obscured by the most important image: a picture of Ryan with his favorite sister, Karen. Ryan told me she worked downtown and took the bus up Madison Street to see him.

Ryan passed away peacefully on Sunday, February 28, 1993. He had been in a coma for three days and then stopped breathing. He was thirty-one years old.

Vincent Bacho. SEATTLE. 1984

Kiyoshi (left) and Misa Shikuma. SEATTLE 1992

Sun Yang walked down the trail at the Arboretum, carrying a folding stool, a bag full of paint and brushes, and a large folder as he searched for the same birch trees he had begun painting the day before. At the end of the trail, near an open field, Yang found the scene he was looking for.

"Every day I go out and paint. Sometime half an hour, two hours, or all day," he said, as he unfolded his stool and sat down. He reached inside his bag and took out a palette of watercolors and an assortment of Chinese brushes. Carefully, he untied the string to a large, hard-backed folder containing his paintings. He placed the folder on top of his bag, using it as a small table. He took out a plastic bottle of water with a red nozzle on the end and sprayed the surface of the painting. This helped the canvas absorb his favorite colors: blue and green.

"Don't use easel. Water runs down," Sun said. "Controlling water is important; too much no good."

As he began painting, Yang looked up occasionally to observe the birch trees as they swayed gently from the passing breeze. He looked down at the palette to choose a color.

Yang, sixty-nine years old at the time of this photo, had come to Seattle four months before to stay with his daughter Susan. He hoped that in three years he could immigrate here permanently with his wife.

Yang traveled around the city on the bus or on foot as he visited Lake Washington, Lake Union, West Point, and Golden Gardens—wherever he found the notion to paint.

"Many American people like my paintings of trees in the Arboretum," Sun said. "There is so much water and trees. I like Seattle, but I like China better. More nature. The beauty of nature is exciting. It gives me emotion." As a teenager, Yang painted the landscapes near his home town of Anhui, in central east China. "My father don't like me painting at home, so I go outside. It was a beautiful place."

At age seventeen, Yang took painting lessons from Tan So Ping, a famous teacher at the Central Art University in Peking. "I first learned painting. Then work as a professor of art. In China, artisans have jobs. Teaching is high paying. People respect you." He had taught painting at the Shanghai Cultural Bureau, the Shanghai Movie College and the Shanghai Sun Art Studio. In 1985, Yang had become a senior faculty member of the Shanghai Culture and History Research Institute.

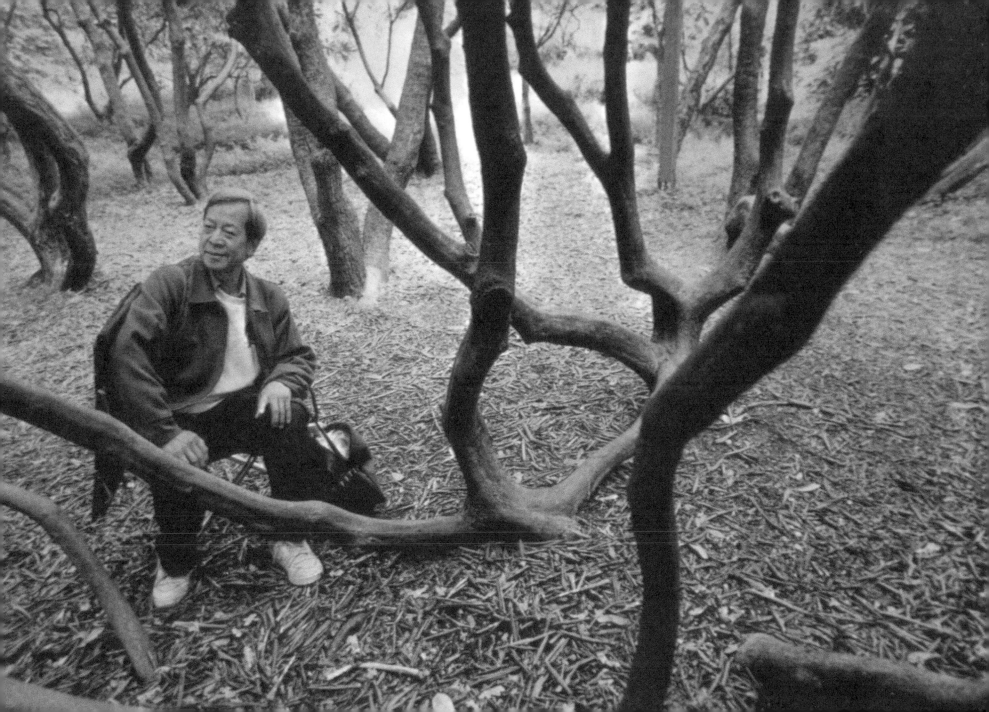

Dith Pran, Cambodian photojournalist. SEATTLE 1998

When I met him, Yang had exhibited his work in China, Japan, Hong Kong, Korea, Taiwan and in Switzerland. In Seattle, some of his work was on display at the Burnley/Blume Gallery in Madison Park. Sun says he is famous in China for his paintings of goldfish. "During the Cultural Revolution, people not free. I saw fish as free. So I like to paint. I went to the zoo to paint golden fish."

Yang's favorite painting was a waterfall, done in Hunan Province in 1984, which he titled *Natural Bridge*. A Chinese legend claims that it takes a stone ten minutes to fall from the top of the waterfall to the bottom.

"Every place have beautiful landscape," said Yang, pointing out some cherry trees he had painted a few weeks before. The trees were covered with pink flowers for the image. When I was with him, the branches were bare.

"I like painting this place. I like to paint and show people. I paint for people, not for me. My love for people," Yang said, as he places his hand over his heart. "Seem like I'm young, not old. I climb mountains, go all around the country. It helps me be young, always happy, artist, to search for beauty to search for life."

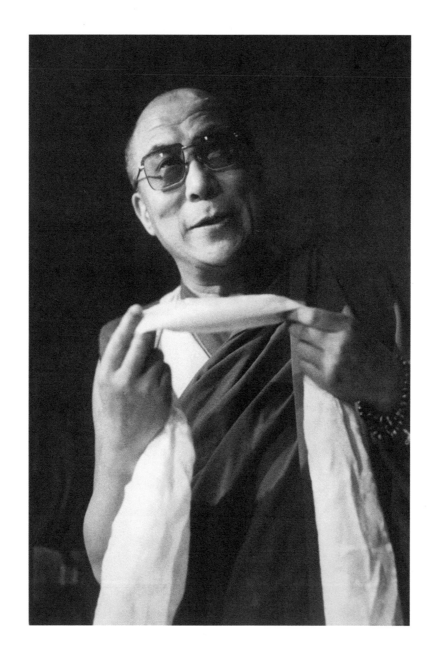

14th Dalai Lama. SEATTLE 1993

Charlie Chong. SEATTLE 1996

Eun-Gyong Lee maintained a brisk pace walking down Boren Avenue, one that would have left some people struggling to keep up. As she crossed each street, Lee could probe her way with a white cane.

Lee had been legally blind since birth. She could make out a few colors, but that was all. When the weather was overcast, Lee could see the red, green and yellow of traffic signals better, making it easier to know when it was safe to cross. In bright sunlight, Lee was totally blind and listened to the sounds of traffic around her to know when it was safe to step into the street. She had learned these skills while attending boarding schools near Busan, South Korea, where she was born.

In 1984, an organization called Heal the Children had brought Lee to Seattle to undergo eye surgery at Swedish Hospital. The surgery had improved her vision slightly, but she remained legally blind.

"It was scary coming here at age sixteen. I cried for a long time because I was unhappy. I missed home. I did not know the language." She knew some words in English, but couldn't put them together to convey the messages she wanted to express.

Lee lived in Puyallup with a host family, becoming only the second blind person to ever graduate from Puyallup High School. From there, she enrolled at the University of Washington to study English literature. "I had some idea about wanting to understand culture better by studying language and literature itself," she said. She often felt she had to try harder in class and do well because of her handicap. She didn't go shopping for fun like other people and didn't go to the popular movies, so there weren't topics she could discuss with class-mates. "I was so disappointed when I first went to the university. I thought people in college were brighter and had something to offer in return."

She felt she had four things going against her. Her blindness, her height (4 feet 9 inches), her gender, and her race. "I feel there isn't just one thing. It's a hassle having all those against you. Being Asian, being a woman is not a crisis. But having all those things against [me] gets me upset. The four things have made me stronger to a degree. But to a degree, it weakened me too, being small and being a woman," Lee said. "In Korea, I was considered cute. People were always willing to do things for me. When I came here, because that sort of treatment was not happening, that made me a little stronger. Being in a foreign country, having to survive, in that respect, it made me stronger."

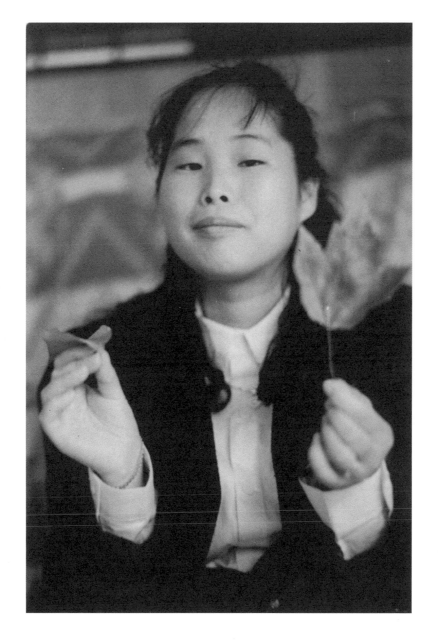

Eun-Gyong Lee. SEATTLE 1995

Climbing 7th Avenue. SEATTLE 1993

Lee worked as a customer representative at the *Seattle Times*, answering circulation calls. She wanted to go back to school to get a teaching certificate. Her ultimate goal was to teach at the college level or become an ESL (English as a Second Language) instructor. "I think it's important for persons teaching to know what it is like to be from a different culture," she said.

Lee and her husband, Mark Rossow, lived in a small apartment with their two cats, Mica and Schatz. Occasionally, they'd go the movies. Lee used binoculars to see details on the screen.

"I would like to take pictures. There was a book of photographs, taken by low-vision people. They said to use fast film, to take something quick and freeze it. Use depth of field," Lee said. When I handed her an autofocus camera to borrow for a few weeks, she picked it up and held it close to her face. Looking through the viewfinder, all she could see was a bright red diode that indicated exposure. Since Lee could see colors, she wanted to try photographing flowers. "It sounds fascinating, because a lot of blind people don't do it."

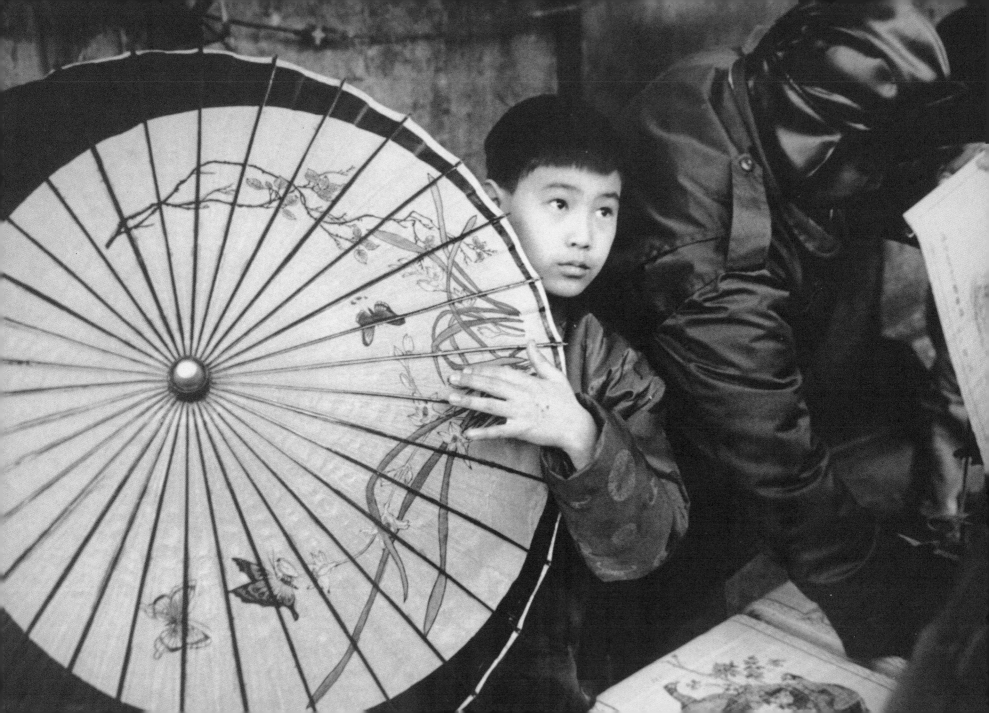

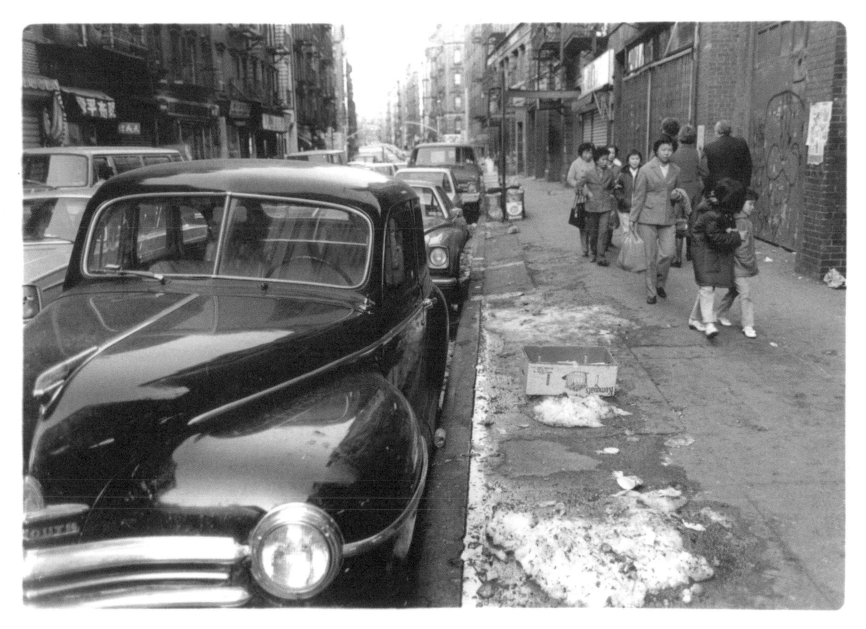

NEW YORK CITY 1983

FACING: **Umbrella Boy.** CHINATOWN, NEW YORK CITY 1983

NEW YORK CITY 1983

VANCOUVER, BC 1992

5

A
FAMILY

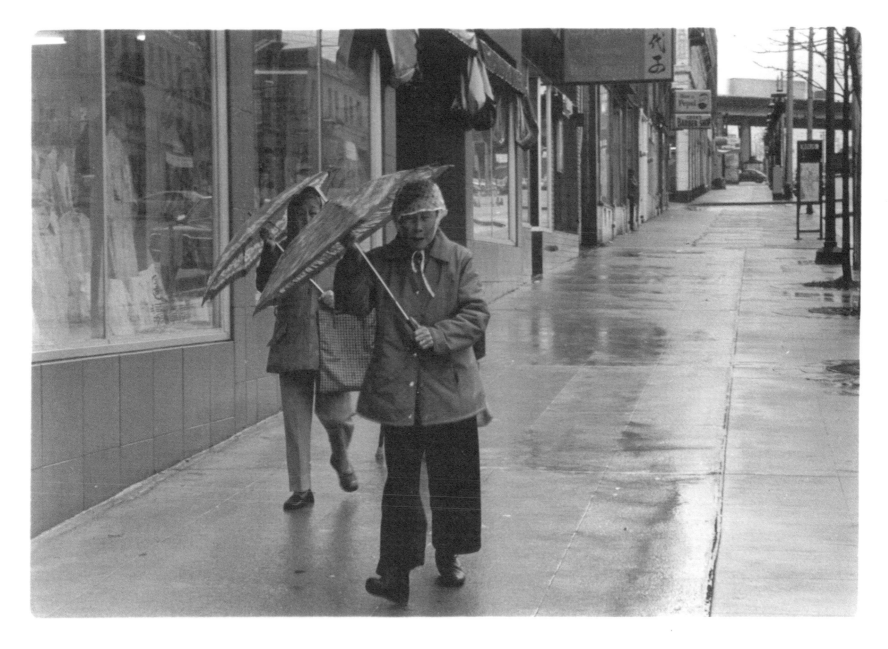

Passing Higo in the Rain. SEATTLE 1984

90

SEATTLE 1986

When I decided to visit my mother at Lakeview Cemetery the first Christmas after her death, I thought about buying flowers.

"She wouldn't want you to spend that kind of money. You know how she was," said my wife Jan as we drove towards Lakeview. Jan was right. My mother was frugal and would never pay money for such luxuries, choosing to grow flowers in her yard instead. She was 101 years old when she was laid to rest next to my father on May 4, 2012. Since my mother's death, I had learned to count the rows of headstones to find the family plot. It's in row seven, to the right of the entrance.

With my fingers, I found the freshly-engraved date beside her name. I did the traditional bowing three times, then clean-up around the headstone, picking up loose leaves just as she did countless times for my father, who passed away when I was in the sixth grade.

Years ago, when I was young and both my parents had been alive, we had celebrated our Christmas holidays in Chinatown. My mother and father would sometimes buy a small Christmas tree. It was never a fancy one like you'd see in department stores. The branches would be uneven; its overall shape was usually unruly; but it was a Christmas tree. A few lights and ornaments made it look colorful. It smelled like a tree and felt like it too.

I was just a little boy and the old storefront space my family lived in on King Street did not have a fireplace. I wanted to believe in Santa Claus; I read all the stories about his reindeer delivering presents to kids in his sled. Since we didn't have a chimney, I always wondered if Santa would make it to my living room with his gifts.

We had an aunt from San Diego who would often visit. Each time she came to our home, auntie would bring us toys. Her occasional visits during Christmas were something to look forward to. In many ways, she was our Santa Claus, without the red suit and white beard.

My mother ran the Re-New Cleaners on Maynard Avenue. My father owned a restaurant with a friend. When I was eleven, my father passed away. With four children to raise alone, my mother ran a tight household. After the bills were paid and groceries purchased, there wasn't much money for presents. She sacrificed for her children. While her two sons and two daughters ate the legs, breast and wings from the plate of soy sauce chicken, my mother would pick on the back, neck and bony pieces, filling up on white rice. Often times we'd open our gifts and inside would be clothing my mother made by hand. "If you wear clean clothes, no one will ever know you're hungry," was one of her favorite sayings.

Her seamstress skills were a big part of her laundry business and something she learned as a teenager in China. My mother and father came from the city of Canton, China, more than forty-five years ago to begin a new life in a land Chinese immigrants once called Gold Mountain. My mother did not talk about family history much. The one story she always told was of going to Broadway School to learn English for three weeks, then quitting to open a hand laundry in Chinatown. She kept a picture on her dresser for years. It's a formal portrait taken in a Chinese photography studio. She's holding a fan, wearing a Chinese dress, and sitting on an ornate chair.

"By the time I came to this country, there were a lot of Chinese arriving here. Men, women and children. A lot of people were coming at the same time. They were mostly related to the US servicemen." She arrived in Seattle in 1947 went into the laundry business the next year.

As I got older, I helped translate when it was necessary. I helped do some ironing and delivered aprons to Chinatown restaurants, but she did most of the skilled work. "I had to take in the laundry, repair zippers, do alterations and iron," she said. Using the pages of Chinese newspapers, she would carefully fold shirts and use the paper to keep the shirts flat. The pages would poke out with Chinese calligraphy showing. The laundry would be wrapped in butcher paper and tied with string. The hours were long, nearly twelve hours a day, six days a week at one point. During the summer months, the laundry would heat up, especially near the press. Raising four children was not easy for a working mother. "It was a lot of work. I had to take care of my children at the same time I was working. One would be in a baby carriage and the other would be grabbing on to my sleeve."

My mother saved her money and eventually had enough for a down payment on a house. We moved to Beacon Hill. Surrounded by White neighbors, our Christmas celebrations became more mainstream. The children in the family were growing up and we became more Americanized. But staying with tradition, my mother would continue brewing exotic soups said to be essential for our good health. She washed her tired feet in a liquid from boiled roots. Insisting that we maintain our language, we were required to speak Chinese in the home.

My mother spent the last years of her life living at the Kin On Health Care Facility, a non-profit nursing home for Chinese elders. Her memory was ravaged by Alzheimer's disease and she had trouble recognizing her own children, but the family did its best to maintain a connection with her. Each December, the nursing home would be decorated for the holidays. The Christmas tree would be brightly lit, bringing warmth and comfort as church groups visited with their choirs.

On Christmas, it never mattered if my mother didn't remember who I was. We remembered all she'd done for us. It made it more important than ever for my family to celebrate each day like it was Christmas, as long as our mother was with us.

———

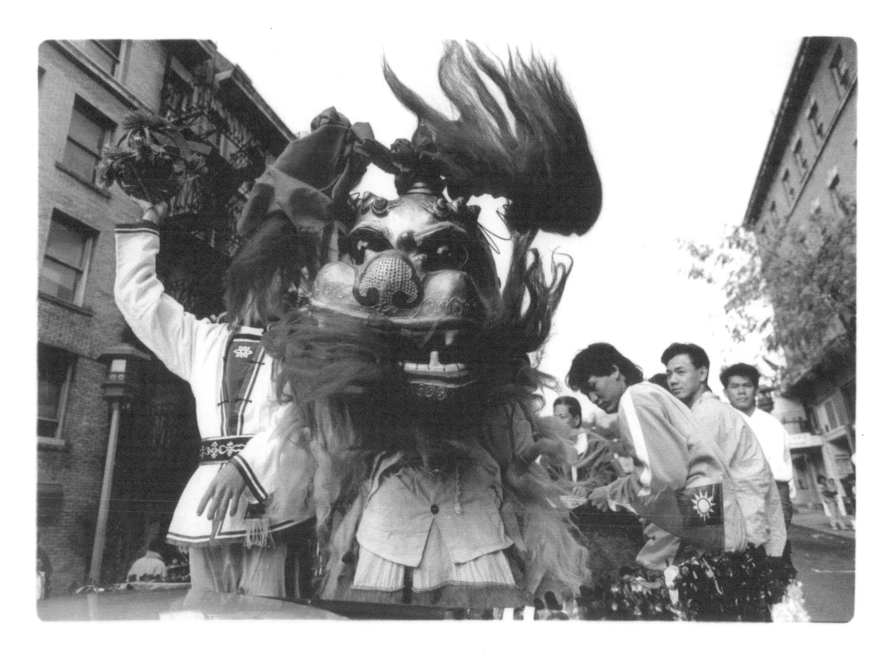

Double Ten Celebration. SEATTLE 1984

HING HAY PARK, SEATTLE 1991

A week before the New Year, my family cleaned the entire house. My mother placed oranges and tangerines in all of the rooms for good fortune. She made us observe strict rules. "Do not drop your chopsticks," she said. "Do not say anything that will bring us bad luck." For an offering to our ancestors, my mother placed a boiled chicken, complete with head and feet on a platter. She would add roasted pork, pastries, oranges, *lai see* and incense around it. The offering would be placed by an open door, the smoke from the incense rising into heaven. The Chinese believe their ancestors will come back to visit during the holiday. The chicken, left intact with head and feet, symbolizes the wish that the family remain united throughout life.

The date of Chinese New Year changes according to the lunar calendar, but the holiday usually falls in late January or early February. Each year in the Chinese calendar is represented by one of twelve animals: rat, ox, tiger, rabbit, ram, monkey, cock, dog and pig. Many Chinese learn the chronological order of the animals from their grandparents. The story, passed down through generations, begins with an emperor who let the animals race to decide their order. During the race, the rat sat on the back of the steadily moving ox. Near the finish line, the rat jumped off the ox's back and won the contest.

SEATTLE 1989

TRINITY CHURCH, SEATTLE 1993

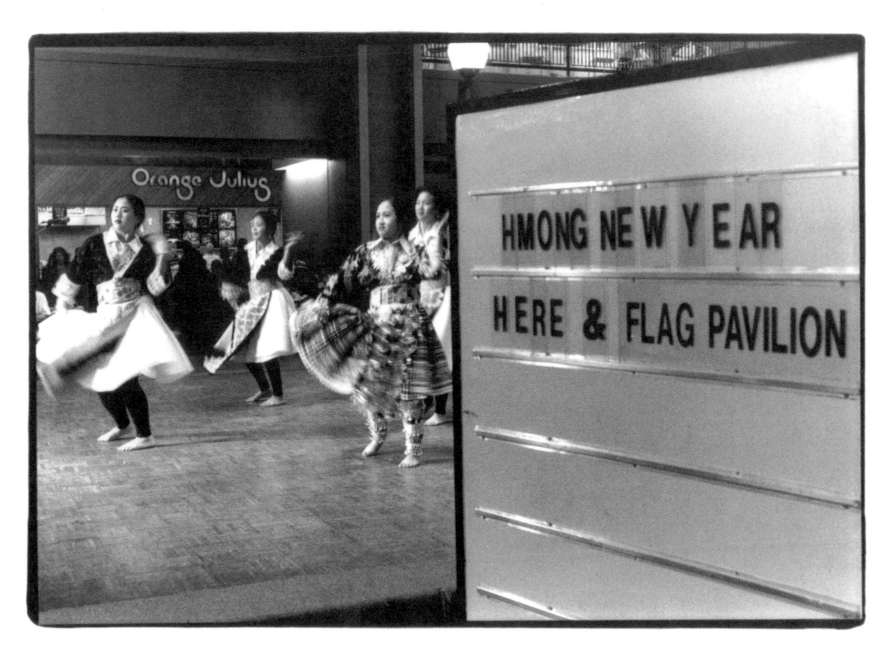

HMONG NEW YEAR
HERE & FLAG PAVILION

98

SEATTLE 1988

I was born in 1954, the Year of the Horse. I was just a typical Chinatown kid, following the lion dancers as they performed in front of businesses to bring good luck and prosperity for the New Year. Like other Chinese boys, I was fascinated with the colorful papier-mâché beast and the firecrackers exploding with sounds audible several blocks away. Merchants tied strings full of money and lettuce in their doorways as an offering to the lion. Before taking the money, the lion "ate" the lettuce. If offered the entire head of lettuce, the lion tossed it into the air, then kicked it, scattering leaves all over. The lion would grab the money or red envelopes before bowing three times to show its gratitude. Firecrackers would explode, the smoke often obscuring the lion's head as it pranced about. The banging noise from the firecrackers and the musicians playing drums, cymbals, and a gong scared away demons and misfortune.

Most Chinese Americans can recall with fond memories, the *lai see*, red envelopes filled with money, given to us by my parents, relatives and friends. Red is a symbol of happiness. Red banners with Chinese calligraphy would be hung on the walls. The New Year greetings or family wish lists brought good luck to the home.

Some families buy fish for the holiday, because fish represent saving money. Others prefer crab, believing this increased their fortune when playing the lottery or gambling. Single people wishing to be married in the new year purchased branches of flowering peach to increase the chance of romance. The Kitchen God found in many Chinese homes observes the family's morals during the new year. A piece of brown sugar is placed on the Kitchen God's altar so it would have good things to say about the family upon returning to heaven.

Over the years, some of these traditions have disappeared with the passing generations. Some customs remain. The sounds of firecrackers still echo off the walls of Chinatown's brick buildings. The banging of the drum, clanging of the cymbal and colorful swirl of twisting and turning lion head go on.

Some traditions will never change.
That's a good thing.

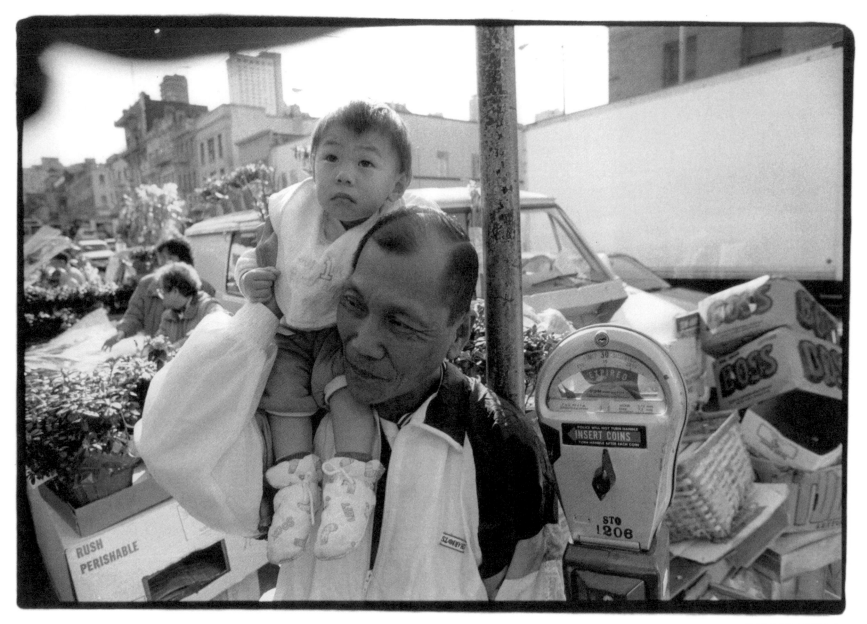

STOCKTON STREET, SAN FRANCISCO 1992

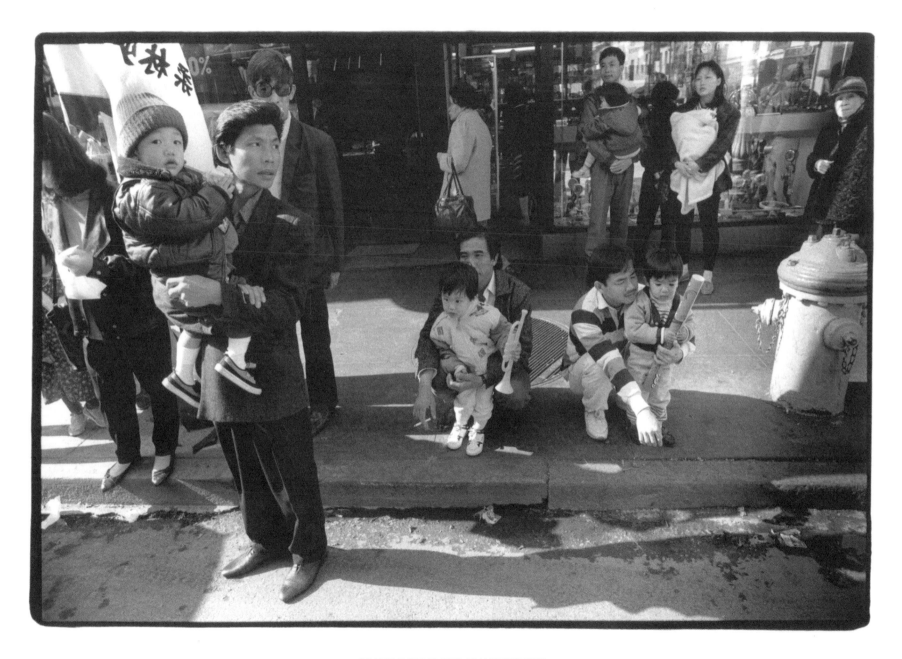

GRANT AVENUE, SAN FRANCISCO 1993

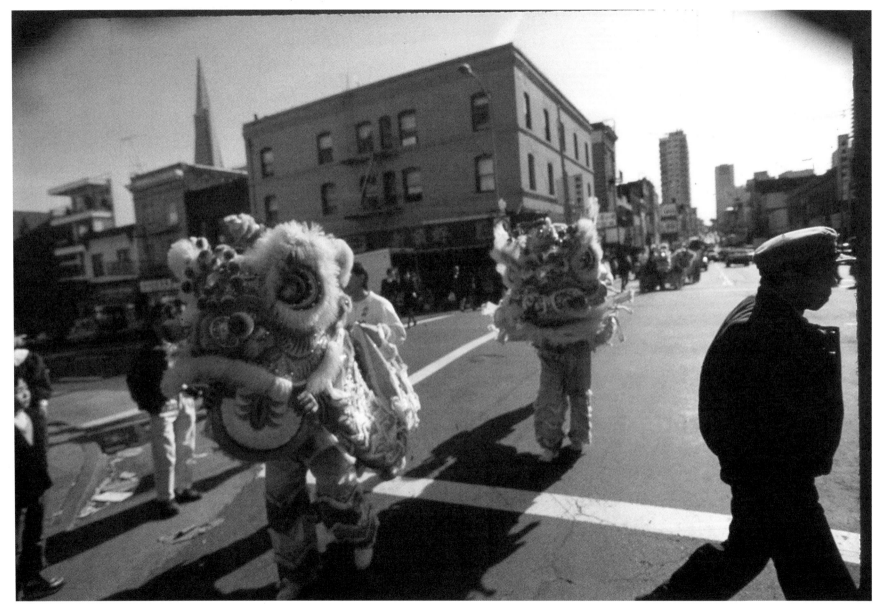

STOCKTON STREET, SAN FRANCISCO 1992

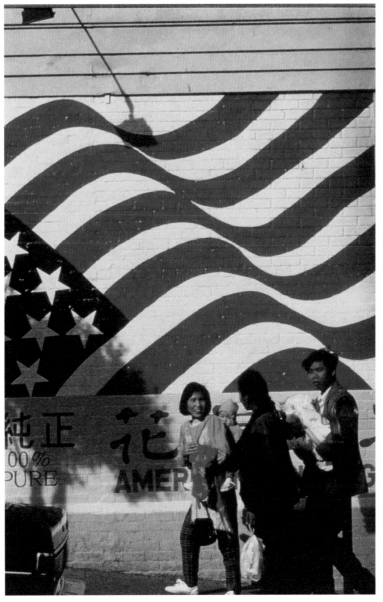

100% Pure. SAN FRANCISCO 1992

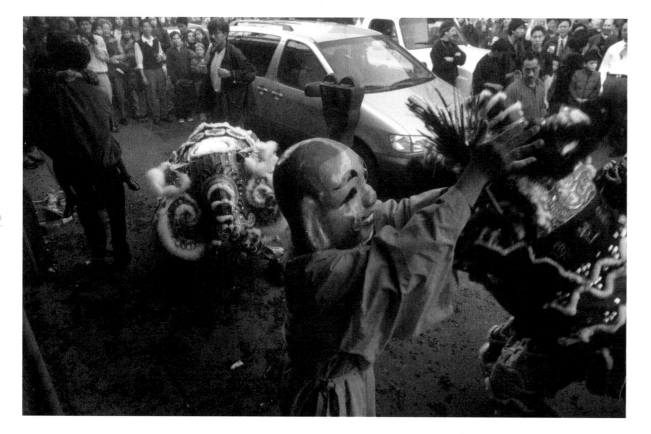

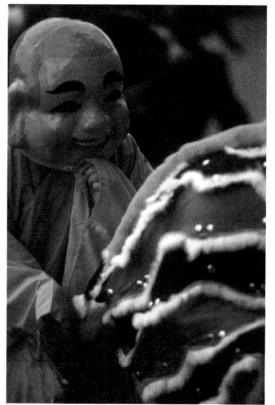

CHINESE NEW YEAR, SEATTLE 2000

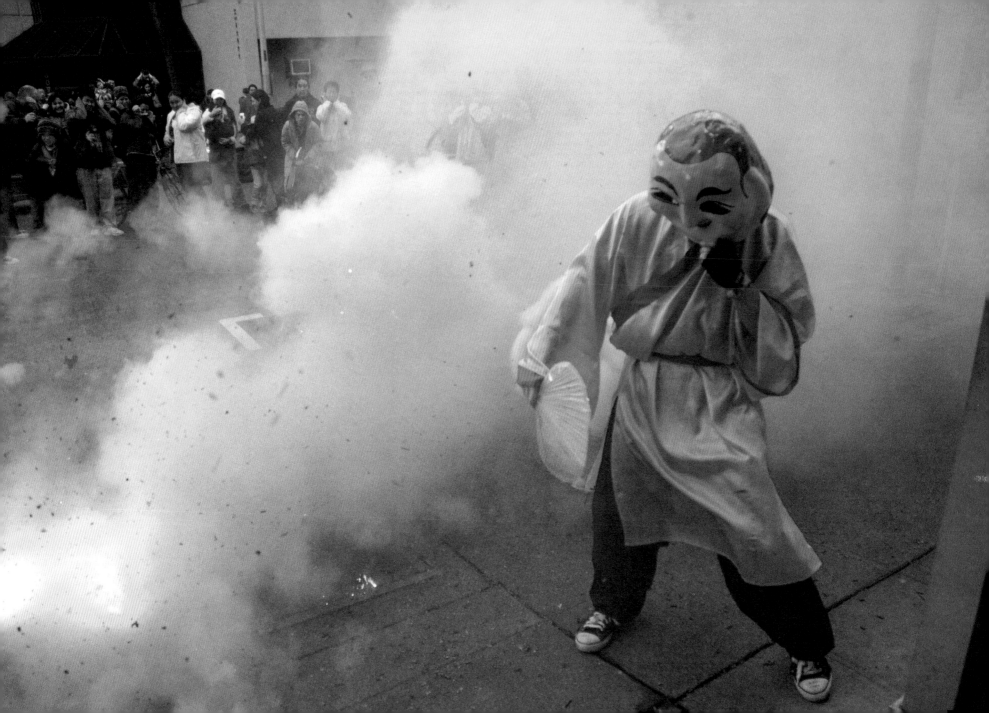

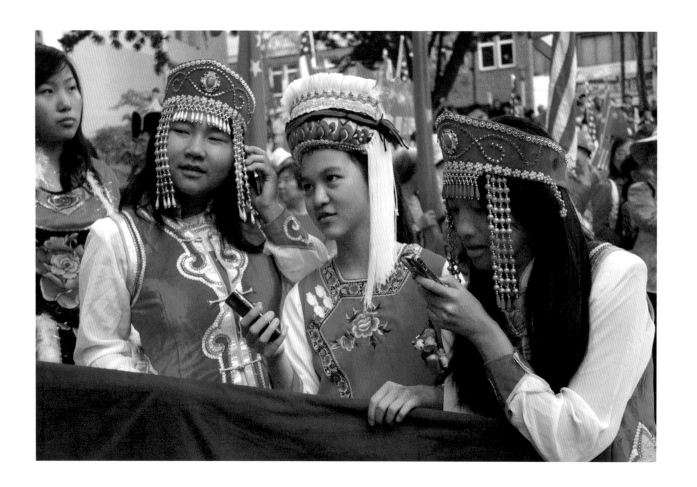

Cell Phone Girls. SEATTLE 2009

#36 Boy. SEATTLE 2008

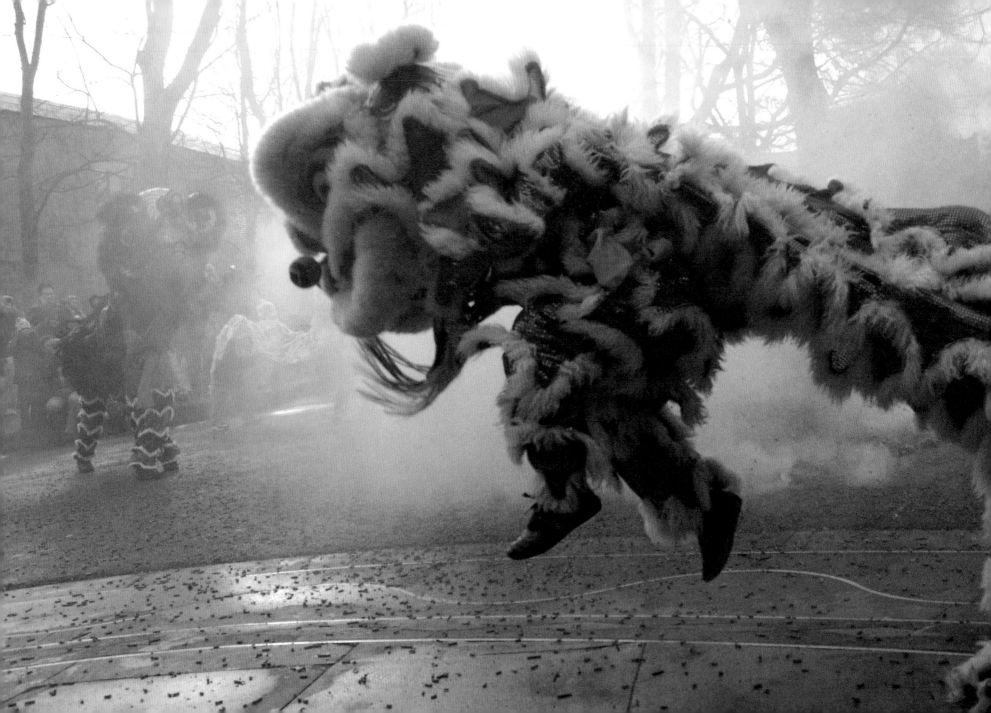

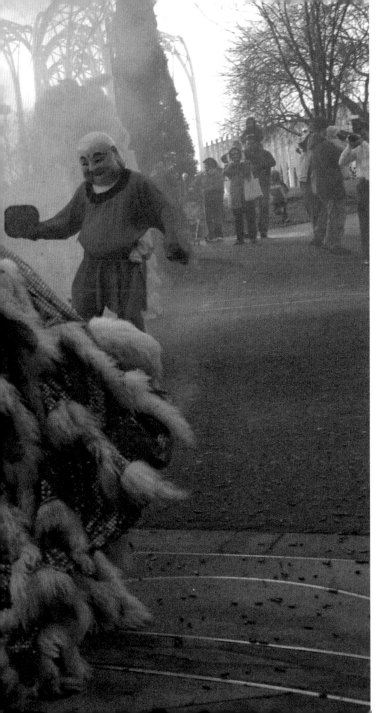

Tet Lunar New Year. SEATTLE 2008

6

A
FIGHT

Kung Fu student. SEATTLE 2008

SEATTLE 1993

Taky Kimura heard about the kung fu artist with impressive skills and had to see for himself. Some friends urged Kimura, who had been studying judo, to make a move on the newcomer, who was only nineteen.

Kimura threw a punch. Missed.

The young Chinese man sent his fists flying, stopping inches from Kimura's face. "I could feel the blows coming to me," he remembered. "He could come so close I could feel the wind; it was enough to knock you back. He took me down. It was incredible. He was unbelievably talented."

This was Seattle's introduction to Bruce Lee, who would later become a worldwide legend.

Kimura realized Lee had a special talent as a fighter and became his assistant and one of his best friends. When I interviewed him in 1994, Kimura was the president of two supermarkets and a trading company. Hanging on a wall were pictures and a certificate signed by Lee when Kimura studied under him.

James DeMile, another martial artist who studied under Lee, became grandmaster of the Wing Chun Do Gung-Fu school in North Seattle. He said Lee was just a "punk kid" when he arrived here from Hong Kong in 1959 at the age of eighteen. "We hung out quite a bit, fighting in the hallways, holding impromptu training sessions."

Lee attended Edison Technical School (now Seattle Central College) and found a group of friends to hang out with. Many of them were "street fighters," DeMile said. Lee was constantly flaunting his ability and irritated some classmates. Artist Roger Shimomura, who attended the University of Washington with Lee, recalled, "He used to pump up his forearm; it literally would expand. He would make you feel how hard it was."

His new friends urged Lee to start a kung fu school. He rented space at Maynard Avenue and Weller Street in Chinatown. The school was later moved to a basement at Eighth Avenue and South King Street, before it relocated to the University District. Before opening the school, Lee had shared his martial arts knowledge with his friends for free. After he started his classes, the style he taught changed. "He changed his stance," DeMile said. "Added some things. He said, 'why should I teach someone to beat me?'"

Ted Munar still remembered December 7, 1941, the day of the Japanese attack on Pearl Harbor. Only five years old, his friends had turned against him and beat him up. "I was no longer American. I was not considered Filipino. I was a Jap. Not a Japanese," he recalled. "Things like this flash back to me as I get older and it still hurts."

I talked to Munar and another Filipino/Japanese American, Alice Una'Dia, when they came to Seattle in 1994 to give the public an opportunity to learn more about the internment of 110,000 people of Japanese ancestry. Over 1,500 Asians, who were of mixed race or were mistaken for Japanese, were also interned.

Alice Una'Dia and her family were relocated from their strawberry farm in Madeira, California, to the Fresno Assembly Center Fairgrounds, where they joined five thousand other Japanese American internees behind barbed wire fences. Una'Dia's mother, who was of Hawaiian/Japanese descent, turned down an arranged marriage and went to work in a pineapple plantation, where she met Una'Dia's father. He was Filipino and Spanish, and had moved to California after he was discharged from the United States Navy. They ended up getting married. But in September 1941, Una'Dia's father passed away, leaving behind his wife and seven children.

When Executive Order 9066 was passed to begin the process of interning people of Japanese American ancestry, Una'Dia said her family did not think they would be interned. "Then we got a notice that we had a week to pack."

Munar recalls, "We were supposed to be interned; our suitcase was in the middle of the floor, but some White boys came over and said, 'You don't have to go.'" The order was rescinded because Munar's father was Filipino American.

But by living outside of the camps, Munar was exposed to hatred which had developed against Japanese Americans. "I was out there with the 'enemy.' The beatings I took will forever be imprinted on my backside. My body," said Munar, who learned how to use his fists to defend himself.

Una'Dia says she's proud of being Filipino and Japanese. But she remembers her brother coming home with a bloody nose. He had been beaten and called a "dirty Japanese."

The movies, posters, books, and newspapers of that time reinforced the message, "the Japs did this, the Japs did that," said Munar.

"My heart ached for the Japanese who lost life savings and were interned for three years. It was a flagrant violation of our constitutional rights," she said. After four months in camp, her family returned home to Maderia. Fortunately, some friends had taken care of their strawberry patch while they were gone.

Although his family was not interned, Munar says the hurt he experienced while living outside of camp is still deeply imbedded. "Were they prejudiced against us? Definitely," said Munar, "but I'm proud of being Filipino and Japanese. I have so many stories to release to you. But I'm afraid of crying... I wish you could crawl into my body and feel the pain. I'm slowly healing."

Self Portrait. SEATTLE 1982

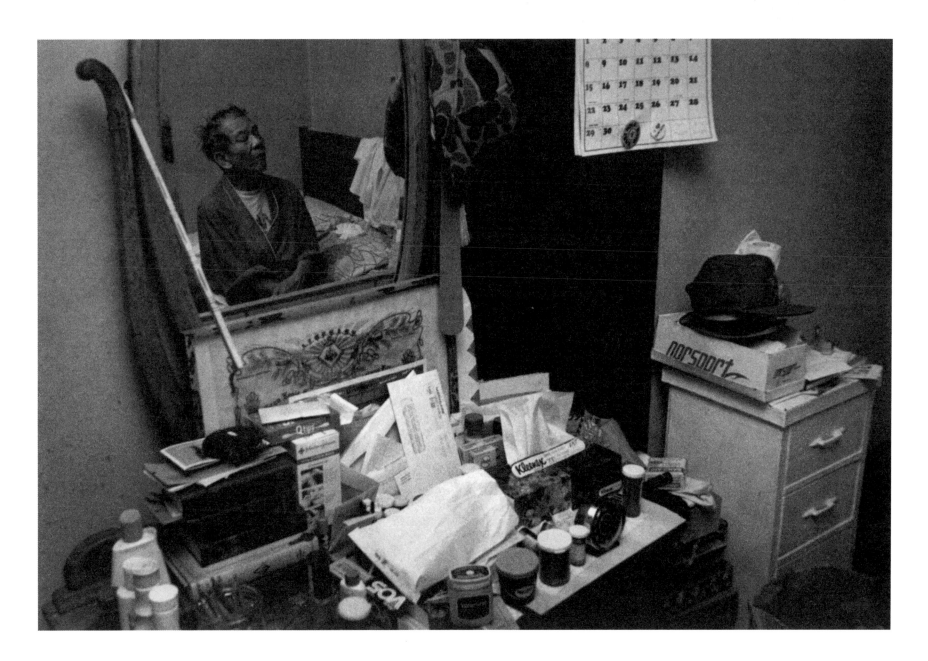

Frank Valdez. SEATTLE 1984

After hearing about the trials of internment and war from elderly veterans and internees, I remember when I saw for myself how war affected families in my community. There were several hundred people waiting on the tarmac at McChord Air Force base on March 12, 1991. Waiting three hours for a loved one to arrive by plane isn't a long time after sixty-two days of watching the Persian Gulf War unfold on CNN with your child in constant danger.

For many, the trip had begun in Seattle around one p.m. Faced with repeated delays, the plane carrying the members of the 50th General Hospital Unit, based at Fort Lewis, appeared in the distance well after four p.m. It had been raining. As the Boeing 747 appeared in the sky, the rain stopped and the sun came out. It was a good sign. When the plane touched down and a small American flag was held out of a window in the plane's cockpit, people went wild, screaming and cheering.

Sixty-two days of worry, watching television reports of Iraqi scud missiles and fearing nerve gas attacks, had taken its toll on those back home. Filled with anxiety and emotion, the families could only hope and pray. Now the end was in sight.

Military Police held the crowd back behind a barrier when the first soldiers began exiting the plane. In the chaos of people rushing towards family, I encountered Andy Cheng, surrounded by his family.

When I pressed the shutter on my camera, Cheng was holding a bouquet of flowers in the right hand, an M-16 rifle slung over his shoulder, his sister behind him crying in happiness. Another sister was patting him on his back. Another relative held an umbrella over his head. Meanwhile, when Francesca Angeles stepped off the plane, her aunt, Carmen Espanol began shouting. "Francie, my baby, my baby."

Angeles was no longer a child. She was two weeks away from twenty-one.

The first night of the war, Angeles slept with her gas mask on. Saudi men stared at the small woman dressed in desert camouflage with an assault rifle on her shoulder.

Espanol met Angeles at the bottom of the plane's ramp and began hugging her. Carmen's mother, Mrs. Nora Espanol, was running up to them with a large bag of celebratory food, good old home cooking. Pancit, rice, Gatorade, peanuts, napkins, forks, and cups. Everything needed for a party.

"The Scuds were scary. I could hear the Patriots [anti-missile system] take off. There were air raids in the middle of the night," she said. "The first night, they woke us up and told us to get into our masks and sleep in them. We couldn't sleep, we were awake all night.

"I'll never be the same again. I'm thankful for what I've got. To have the freedom to say and do what we want." Based in Saudi Arabia, Angeles found the culture different as a female. "They're very offended that there are so many of us [women]. The older men would just stare at us."

Family members insisted on pictures with Angeles, with her helmet and rifle, adding maturity to her young face. The green bag containing her chemical protective gear was still at her side.

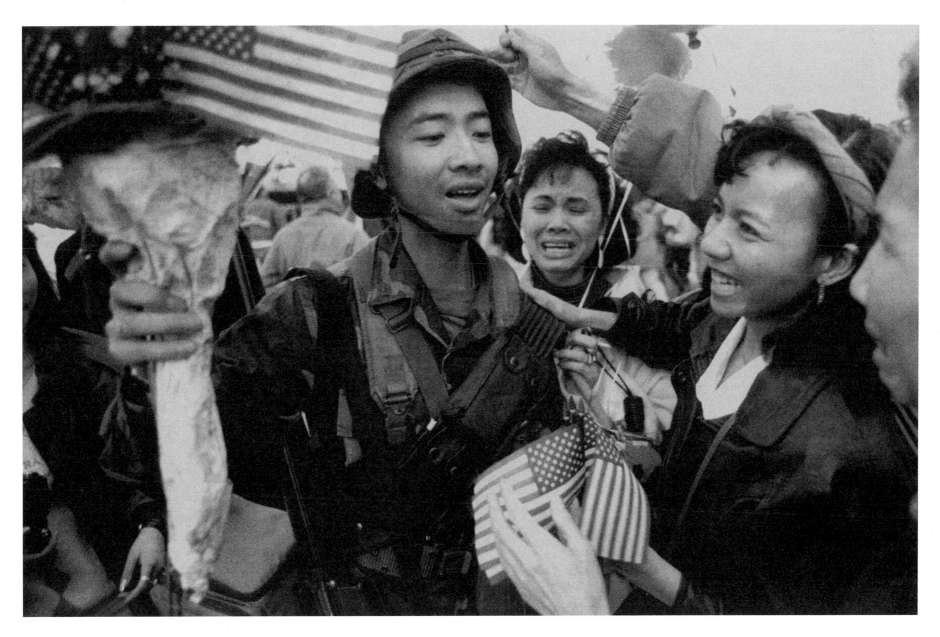

Homecoming. ANDY CHENG. SEATTLE 1991

LEGISLATIVE BUILDING. OLYMPIA 1996

Gary Locke. SEATTLE 1993

The Limptarkuls were from the northern city of
Chiang Mai in Thailand, but did not meet until
they were both living in Los Angeles in 1990. Tito
washed dishes to help pay for college, where he was
studying to become a graphic artist. "I was inter-
ested in art in Thailand," he said. "I worked for a
newspaper, but I had no background or education.
I had artistic talent, enough to get by." Pam received
a broadcast television degree in Thailand. Then,
she attended Hollywood University in Los Angeles
and got a degree in filmmaking. They met through
a mutual friend in the Los Angeles Thai community.
Tito laughed and said he considered it fate, destiny
or punishment that they met.

They moved to Bothell in 1989, and in 1992 they
bought a small Thai restaurant in Canyon Park
Place called Thai Rama. Tito's family has a saying
that has been passed down through the generations:
"Hard work makes luck possible."

"We averaged twelve hours a day at work. There were
no weekends or days off," Tito said.

"Our daughter was two-and-one-half years old and
had to sleep in the back of the restaurant," Pam
recalled. "When she cried, I had to tend to her and
the orders. I put her at the front of the restaurant
so she could watch me."

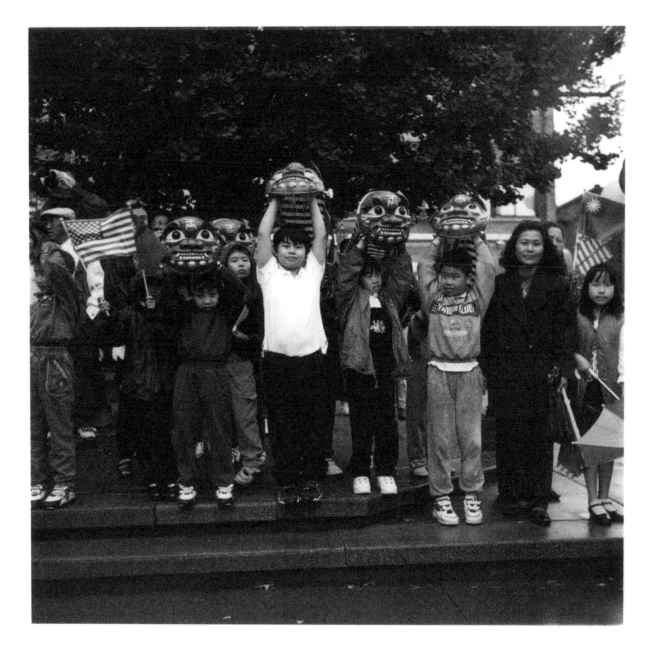

SEATTLE 2005

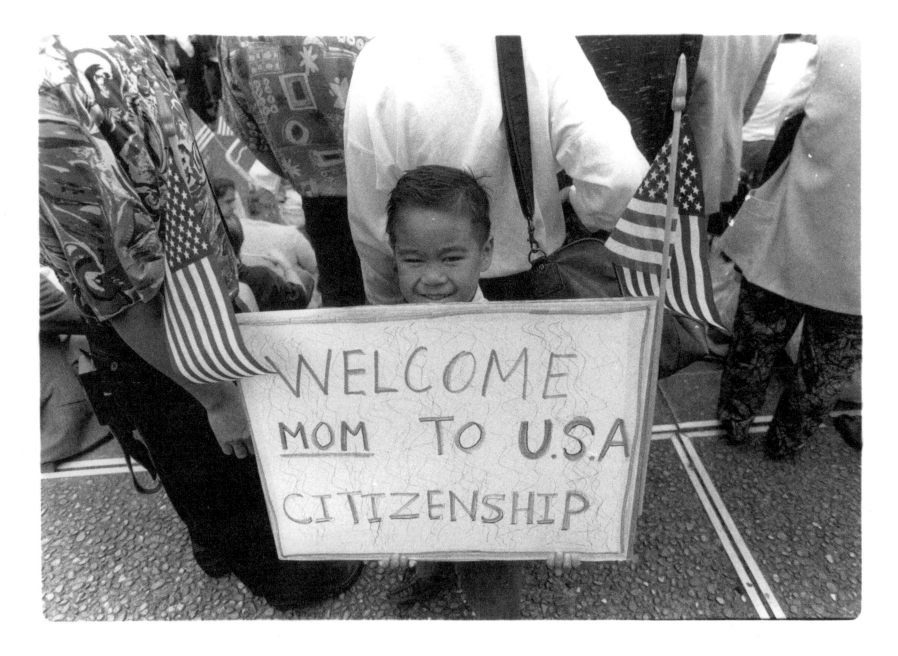

SEATTLE 1984

Then doctors diagnosed the thirty-nine-year-old Tito with rare a medical condition that caused tumors to grow throughout his body. Tito's father had died from the disease and an uncle was left crippled by it. "The hard part is we don't know if our daughter has inherited it," Pam said. "She has a fifty percent chance."

"The sickness happened during the citizenship process," Tito Limptarkul said. "It interrupted our class." Tito knew that he could develop other tumors, but he was fortunate to access modern science to battle the disease, an advantage his father and uncle did not benefit from. And the Limptarkuls had a loyal following among their Bothell customers. A hundred of them were praying for Tito's health. One customer, State Senator Rosemary McAuliffe, helped speed up Tito's citizenship process by arranging for him to take the test ahead of the other members of his class because of a scheduled surgery. Meanwhile, a citizenship instructor gave the Limptarkuls private tutoring since Tito was unable to attend class during his illness.

One spring day, Tito and Pam, with daughter Lily by their side, took the oath of citizenship at the Immigration and Naturalization Service in a room filled with new Americans from all over the world.

"I feel really good," Tito said, after becoming an American citizen. "I feel I belong here psychologically. We want to spend our future here."

Lily was ecstatic to see her parents become citizens.

"She wants us to be here in the US. She's proud to a US citizen herself," said Pam.

When I met the Limptarkuls, Tito was spending more time at home with Lily. He could no longer work at the restaurant as long as he used to, and the stress of the health situation had affected his daughter. "She's nervous," Pam said. "Her teacher said she has become withdrawn from friends. She prays each night and every morning."

Tito and Pam wanted people to know what they'd been through. "Hopefully, our story can encourage young people to have a good life here," Tito said. "We don't look at us as a good example. It's just a good story to tell."

7

SAN
FRANCISCO
2010

F-MARKET TROLLEY

MINNA STREET

As night turned into day, the city of San Francisco came alive with people leaving their homes on their way to work. They were joined by the homeless crawling out of sleeping bags and cardboard shelters in the alleys and doorways of western Market Street. A Chinese woman was already out with her shopping cart, standing under a street sign, ready for a day of rummaging for aluminum cans to recycle for cash. I could see her from the window of my hotel.

In the 1970s, Asian activists referred to American Chinatowns as "ghettos disguised as tourist attractions." Even when I visited in 2010, I still saw Chinatown residents living in the old buildings above stores and restaurants. Laundry and bok choy (*toy goin*) was left to dry hang from windows and fire escapes overlooking the street. My plan was to spend all day roaming this historic neighborhood, searching for the "decisive moments" that create memorable images.

In Portsmouth Square I saw the same sorts of things I'd seen on my visit almost twenty years earlier: locals sharing the news of the day; locals feeding pigeons, or shooing them away; seniors deep into their Tai Chi forms; small groups of gamblers already staking out spots that would provide shade later in the day.

I passed Stockton Street, where Chinatown residents milled around buying their essentials. On Pacific Avenue the Y Ben House Restaurant was already open and filled to capacity. A crowded room in Chinatown means noise. Voices overlap and create a constant hum of Cantonese and Mandarin.

The waitress led me to a table that I shared with an older Chinese couple. They paid no attention as I sat down. There was a long wait until the first cart piled high with bamboo steamers arrived. The woman at the table gestured towards the cart, like she was saying, "Eat!" My breakfast was a couple orders of pork dumplings (*shu mai*) and shrimp balls (*hai gow*). I always order these two items to compare restaurants. My measuring stick for dim sum. These were just ok.

By the time I passed back through Portsmouth Square, a large group had gathered to watch a card game. Players slammed the cards they didn't want onto the bench, screaming in Cantonese each time. The park was now filled with people. Tour groups passed through, throngs of visitors with their maps and cameras.

Gift shops, many selling the same merchandise, were everywhere on Grant Avenue. The same Chinatown T-shirt could sell for $4.99 at one store and $1.99 at another. Herb shops, barbecue restaurants, dim sum, and noodle houses lined every block on streets named Washington, Clay, and Pacific. At the entrance to an unnamed alley, an elderly woman sold Chinese pornography. Further in the alley were open doors with people playing mah-jongg. Bedsheets were hung across the doorways to obscure the views inside.

Just after noon in Ross Alley, I found a barber named Jun Yu. I walked inside his salon and motioned with my fingers like a pair of scissors. As I climbed into the chair, I took out my notebook.

His shop was smaller than a studio apartment and had no running water. He had boxes and newspapers stacked everywhere. Under the counters were radios that had been taken apart waiting to be fixed. Two violin cases and an *erhu* sat on a shelf next to bottles of hair products turned upside down for easy dispensing. There were medicine containers, paper flowers in vases, a huge stack of *Playboy* magazines, bills, combs, and clutter, all layered in years of Chinatown dust. Hanging on a wall, like a shrine, were faded black and white pictures of Frank Sinatra surrounded by cobwebs. His eyes lit up when I asked him about "Ol' Blue Eyes."

"I like his music. He came to town. I see him. Good singer," Yu said.

Yu had been cutting hair for over twenty-five years in this tiny location. He was the third barber in the shop's history. The two others before him passed away.

He asked me how I wanted my hair cut, and then made suggestions in Chinese. My Chinese was as bad as his English. He was wearing an ancient hearing aid that occasionally squealed with loud feedback. A wire led from his ear to an amplifier clipped to his brown vest. I couldn't quite understand him and he couldn't understand me. As he cut, I was unsure what the end result would look like, but I figured the experience was worth a bad haircut. Yu grabbed a bottle of water. He pulled the trigger but nothing came out. I waved off a fruit fly and then passed on the offer of blue hair gel. Do you play the violin? I asked. Yu put a CD into a machine and tucked a worn-looking violin under his chin. He swayed back and forth as he played along with a bluegrass tune. When he stopped, Yu was all smiles. "I still want be professional," he said.

I paid him ten dollars for the haircut and left a two-dollar tip.

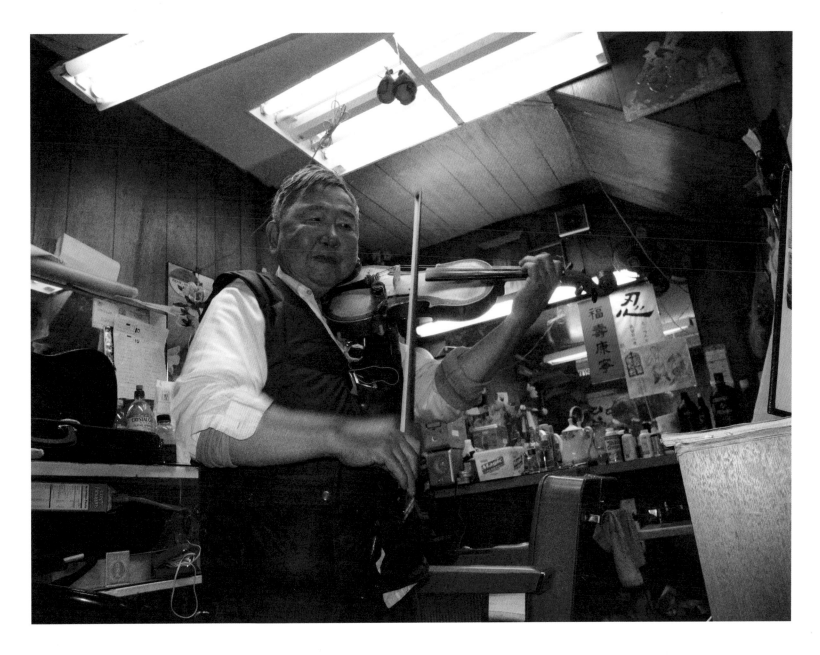

Jun Yu. ROSS ALLEY

Weeks prior to my visit, I had read Bonnie Tsui's book *American Chinatown: A People's History of Five Neighborhoods*. I learned that before the 1906 earthquake, buildings in Chinatown were Western in appearance. After the earthquake, city leaders talked about moving Chinatown south while eyeing the valuable real estate it was built on. Chinese merchants then hired White architects to add Chinese features to buildings in an effort give the community's image a boost.

In her book, Tsui quotes San Francisco Chinatown historian Phil Choy: "What was the first thing they thought of in Chinese architecture? The pagoda. So immediately that becomes the model for the building...Basically they were taking a lot of standard architectural ornaments and creating a new vernacular, neither Chinese nor American, neither East nor West. It's just a figment of the imagination of a White architect...it was because we were promoting our ethnicity to please the White man at the time. It was self-preservation," said Choy.

I lived in San Franciso in the late 1970s. Before this visit, I had not been to Chinatown for about eighteen years. Old dives like the legendary Sam Wo restaurant, where you walked through the kitchen to find a table upstairs, and the Li Po bar with its distinctive round entrance, were still there in 2010. Across from the New Woey Loy Goey restaurant (yes that is the real name), I found Red's Place, one of several drinking establishments in the area.

I asked for a cheap beer. Empty Tsingtao boxes were lined up against the wall. Pictures of customers were taped above the bar. A jukebox played Chinese music. One TV was tuned to a soccer game, the other to a game show. Tired of trying to establish meaningful conversation with the disinterested bartender, I finished my beer and headed back out onto Grant Avenue.

The day was nearing an end and my feet were complaining. I headed back in the direction of the hotel.

STOCKTON STREET

GRANT AVENUE

Walking west on Market Street past Bloomingdales and the Armani store, I stopped to listen to a Latin band in a courtyard. This downtown has a big city feel that is hard to describe. It seems older, more mature and sophisticated than everywhere else.

The music faded and the landscape began to change at Turk Street, where empty storefronts, pawn shops, and topless joints took over. I began to see more and more street people with black plastic bags piled on shopping carts. They stood on the street like there was no place to go. In reality, the street was their home. I was just a visitor.

I searched for someplace on a side street to buy a cold beer. I found a store where people were loitering around with nothing better to do than decorate the drab scenery and intimidate shoppers. Tired of walking, I put on my best "don't fuck with me 'cause I'll kill you" look, entered the store, and made my purchase.

I crossed onto a side street leading straight to the hotel, past a row of color-coordinated condo units. Streetwise habits instinctively kicked in. I turned my back a few times to make sure I hadn't been followed and kept moving at a brisk pace. I scanned the doorways for any signs of potential threats.

A few blocks from my hotel, a handwritten sign on the second floor of the Odd Fellows Temple declared "the world is coming to an end."

Maybe. Some things do change in the city by the Bay. Sam Wo Restaurant closed in 2012 due to fire and health code violations. That ended an era in San Francisco Chinatown, sure. But after much effort, a new Sam Wo at a new Chinatown location opened in 2015. Chinatown plugs on.

8

A
KITCHEN
TABLE

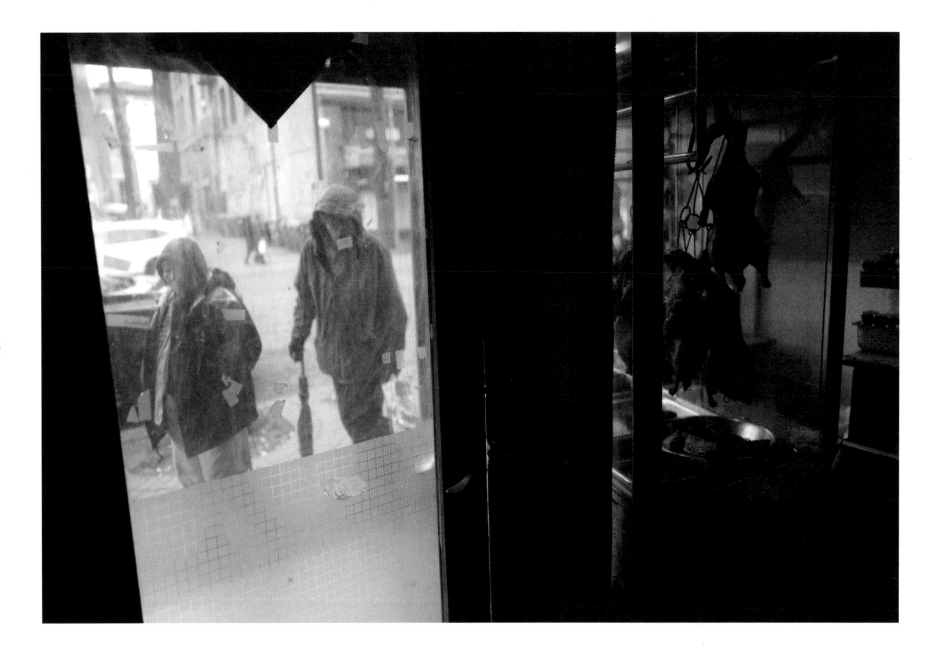

663 BISTRO, SEATTLE 2016

Goodwill didn't want it. The Salvation Army wouldn't pick it up. I thought it would be easy to give away my old kitchen table. So I put an ad in the classified page of the *International Examiner*: "Not too many things are free. But this kitchen table is. It's in good condition, measures 40" x 40" and can be extended with a middle section. So call me for a great deal. Don't need a table? Have a Happy New Year anyways," the ad read.

The very first day, a woman called and said she wanted the table.

The next day, another message. "I saw the ad in the *Examiner*. Does it come with chairs?"

Another call. "This is Irene. I know you gave the table away, but do you have any other free things?"

I started getting calls on my phone machine from people I knew. When they read the ad, it made them smile. Local writers, *Examiner* contributors, and old friends all left me messages that jokingly slipped in a request for the table. Danny Howe, former *Examiner* editor, said: "The five-by-seven prints are just fine for those photos we were talking about. Along with the prints, can I get the kitchen table?"

I had bought the table seven years before at the Sears Outlet Center for forty dollars. During that time, I'd used it for meals, reading the newspaper, framing photographs, and collecting piles of junk. I finally decided to give it a new home when I got a better table, one made of solid wood. I'll admit, I'd procrastinated in finding someone to take the old table. I become attached to things.

When I was growing up with my family in Seattle's Chinatown, we had an old wooden table in the kitchen that must have dated back to the 1950s at least. I can still remember one memorable meal. My brother had just returned from one of his Boy Scout trips with several buckets of snails. My mother steamed them in black bean sauce and invited all of our neighbors over for dinner. Everyone sat around the table, sucking the snails right out of the shells. It was the first time I had tried them. It took me awhile to get up the courage to taste one.

My family finally moved out of Chinatown in 1968. We took the kitchen table with us, wobbly legs and all. At the new house on Beacon Hill, the kitchen resounded with the noise of my mother chopping meat for a favorite family dish called steamed pork. She would use a cleaver to mince the pork, mixing it with Chinese sausage, mushrooms, and water chestnuts. With each downward stroke of the knife, the sound would reverberate through the cutting board, to the table, and then all throughout the house. Thump. Thump. Thump. I would always know dinnertime was near when I heard the sound. It was a reassuring sound, a Chinese mother making comfort food to feed her family. The table was with us for twenty-five years, probably longer. It was still being used in my mother's house when I got that new table and placed my ad in the *Examiner*.

We had another kitchen table. This one was in the back of my mother's laundry, Re-New Cleaners, on Maynard Avenue in Chinatown. This was our second home. The table was usually cluttered with bottles of jam, Chinese herbs, and other odd ingredients used for cooking. I had one of my first birthday parties at this table when I was six years old. I invited some friends who lived on the same block. One of them lived in a grocery store, the other in an old hotel. Most hotels in Chinatown were run by Japanese American families back then. An old White man also came to the party. He was the one who taught me how to ride a bike by pushing me through the hallways of the Adams Hotel next to the Hong Kong Restaurant.

Congee Breakfast. SAN FRANCISCO 2015

SZECHUAN STYLE $ 8.75

SZECHUAN S[..] $ 8.95

$ 9.9

鱼丝, 肉丝
SHREDDED PORK
SZCHUAN STYLE $ 8.95

東江豆腐煲
SEA FOOD BEAN
CAKE POT $ 11.95

TAI TUNG RESTAURANT, SEATTLE 2014

The kitchen table was also a special gathering place for the Yamada family, relatives of an old girlfriend of mine. For about four years, I attended their New Year's get-together. Four generations of the family would celebrate around the grandparent's table. The room was always crowded with family members sitting at a long kitchen table that filled the room, probably large enough to seat at least fifteen people. Near the table was a small couch. The grandchildren's toys would be spread throughout the room. The table would be covered with food. Sushi, teriyaki chicken, mochi, and other sweets. It seemed like the food would never run out. As each holiday passed, I realized the family members were one year older. The children had grown. Time moves on. But the kitchen table was a constant. Always there, to reunite the family. Another holiday, full of memories.

There was one more kitchen table. This one was
on Macondray Lane, at the top of steep Jones Street
in San Francisco's North Beach. The apartment
was tiny and had been handed down from one
sister to another until it finally ended up with
my girlfriend Jan.

I came to visit occasionally. One of those long-
distance relationships. The table in the apartment
was round, with two curved leaves that folded down.
It was new, only a year old. The table was a nice
place to share a glass of wine after an evening at
Pearl's Jazz Club on Columbus. It was relaxing to
sit at it after walking up Jones, Green, and Union
streets. If you've ever been to San Francisco, you
know what I mean by "up."

I put this table back together soon after the old one
was gone. It had a few scratches on it, left by the long
journey from San Francisco to Seattle. The next day,
a newspaper was spread open on the kitchen table,
next to a cup of coffee. Also on the table were some
mail, makeup, and two sets of keys.

This table represented the beginning of a new
chapter in my life.

My wife Janice. May she rest in peace. SEATTLE 1996

INDEX OF IMAGES

ACKNOWLEDGMENTS

———————

For my friends:

Chin Music Press
International Examiner
Asian Counseling and Referral Service
IDEC
Wing Luke Asian Museum
Chinatown International District community

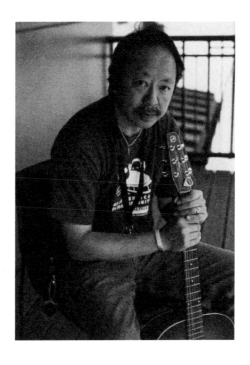

ABOUT THE AUTHOR

As a writer and photographer, Dean Wong has focused on the
Chinatown International District of Seattle and the Asian
Pacific American community. Visiting his neighborhood, the
camera is always ready to capture the next great moment.

COLOPHON

———

This book and cover was designed in Seattle, Washington,
in the winter of 2016 by Dan D Shafer with assistance
from Patrick Perkins. It was printed in Montréal, Quebec,
by Marquis. The type is set in Mrs Eaves by Zusanna Licko
and Montserrat by Julieta Ulanovsky.